INSPIRED GEORGIA

Inspired Georgia

EDITED BY JUDSON MITCHAM, MICHAEL DAVID MURPHY, AND KAREN L. PATY

WITH A PORTFOLIO BY DIANE KIRKLAND

The University of Georgia Press ATHENS Published in cooperation with Georgia Council for the Arts

© 2016 by the University of Georgia Press

Athens, Georgia 30602

www.ugapress.org

All rights reserved

Designed by Erin Kirk New

Set in Garamond Premier Pro

Printed and bound by Thomson-Shore

The paper in this book meets the guidelines for permanence and
durability of the Committee on Production Guidelines for Book Longevity
of the Council on Library Resources.

Most University of Georgia Press titles are available from
popular e-book vendors.

Printed in the United States of America

20 19 18 17 16 C 5 4 3 2 1

Library of Congress Cataloging-in-Publication Data

Names: Mitcham, Judson, editor. | Murphy, Michael David, editor. | Paty,
 Karen L., editor. | Kirkland, Diane, 1955- compiler. | Georgia Council for
 the Arts, issuing body.
Title: Inspired Georgia / Edited by Judson Mitcham, Michael David Murphy, and
 Karen L. Paty ; with a portfolio by Diane Kirkland.
Description: Athens : The University of Georgia Press ; Published in
 cooperation with the Georgia Council for the Arts, 2016. | Includes
 bibliographical references.
Identifiers: LCCN 2016006366 | ISBN 9780820349343 (hard
 bound : alk. paper)
Subjects: LCSH: American poetry—Georgia. | Georgia—Poetry. |
 Georgia—Pictorial works.
Classification: LCC PS558.G4 I57 2016 |
 DDC811/.60809758—dc23
LC record available at https://lccn.loc.gov/2016006366

COVER PHOTOGRAPH: Yancey, *Roots*, 2013

Contents

Acknowledgments

This project was envisioned as an opportunity to pay homage to the ecology, terrain, and culture of Georgia that attracts, nurtures, and fuels artistry and intellect. The editors would like to express their deepest gratitude to all of the remarkable artists who have felt and responded to that pull and by birth or by choice found their muse in Georgia. The vision, talent, and innovation with which these artists infuse our state brings connectivity, shared identity, economic vitality, increased tourism, improved educational outcomes, workforce development, and a robust cultural climate for Georgia's communities. Georgia's artists play a critical role in how we build the future of our state while preserving the legacy of those who came before, and for that we are indebted to them. The editors would also like to express their thanks to the partners and funders who allowed this project to flourish: the University of Georgia Press, Atlanta Celebrates Photography, Georgia Humanities, Georgia Council for the Arts, and the Georgia Department of Economic Development. Generous funding for this project was provided by the National Endowment for the Arts.

Introduction

Inspired Georgia offers parallel anthologies featuring the works of living Georgia poets and photographers. Neither the poems nor the photographs are derivative of the other. The poems were chosen from published collections, and the photographers submitted work without having seen the poetry.

Roland Barthes discussed two elements in a photograph: the studium, which is roughly the subject matter ("the figures, the faces, the gestures, the settings, the actions"), and the punctum ("an element which rises from the scene, shoots out like an arrow, and pierces me"). Readers of this collection will wonder why I chose the poems I did. I chose them because, without exception, there was something in the poem equivalent to the punctum—something that rose from the scene and stung or bruised me, perhaps with sharp delight.

The state of Georgia is rich in poets. I was humbled and exhilarated by the work I read, as well as increasingly frustrated that we would not be able to include every worthy poet. I kept returning to the words of James Dickey, cited in an essay by David Bottoms, who tells us of a phone conversation he had with Dickey a few days before he died. Dickey "said something that has stuck with me. He said, 'The goal of the poet is to make the world more available.'"

I believe every page of *Inspired Georgia* makes the world more available.

JUDSON MITCHAM

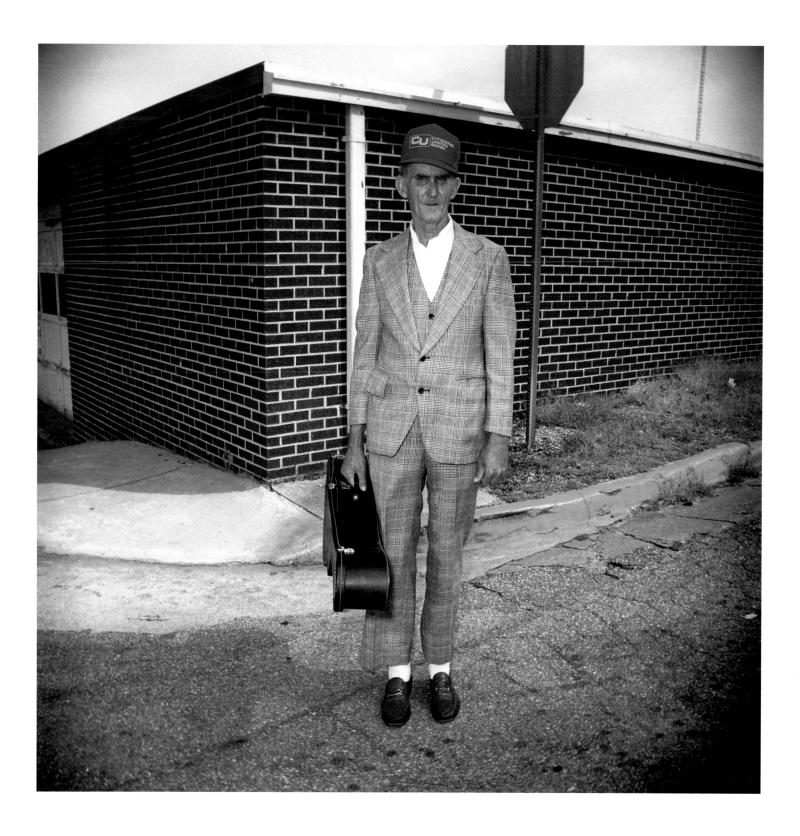

Carl Martin, *Men of Georgia* (1992–1994)

Prelude

A. E. STALLINGS

Lately, at the beginning of concerts when
The first-chair violin
Plays the A four-forty and the bows
Go whirring about the instruments like wings
Over unfingered strings,
The cycling fifths, spectral arpeggios,

As the oboe lights the pure torch of the note,
Something in my throat
Constricts and tears are startled to my eyes
Helplessly. And lately when I stand
Torn ticket in my hand
In the foyers of museums I surprise

You with a quaver in my rote reply—
Again I overbrim
And corners of the room go prismed, dim.
You'd like to think that it is Truth and Art
That I am shaken by,
So that I must discharge a freighted heart;

But it is not when cellos shoulder the tune,
Nor changing of the key
Nor resolution of disharmony
That makes me almost tremble, and it is not
The ambered afternoon
Slanting through motes of dust a painter caught

Four hundred years ago as someone stands
Opening the blank
Future like a letter in her hands.
It is not masterpieces of first rank,
Not something made
By once-warm fingers, nothing painted, played.

No, no. It is something else. It is something raw
That suddenly falls
Upon me at the start, like loss or awe—
The vertigo of possibility—
The pictures I don't see,
The open strings, the perfect intervals.

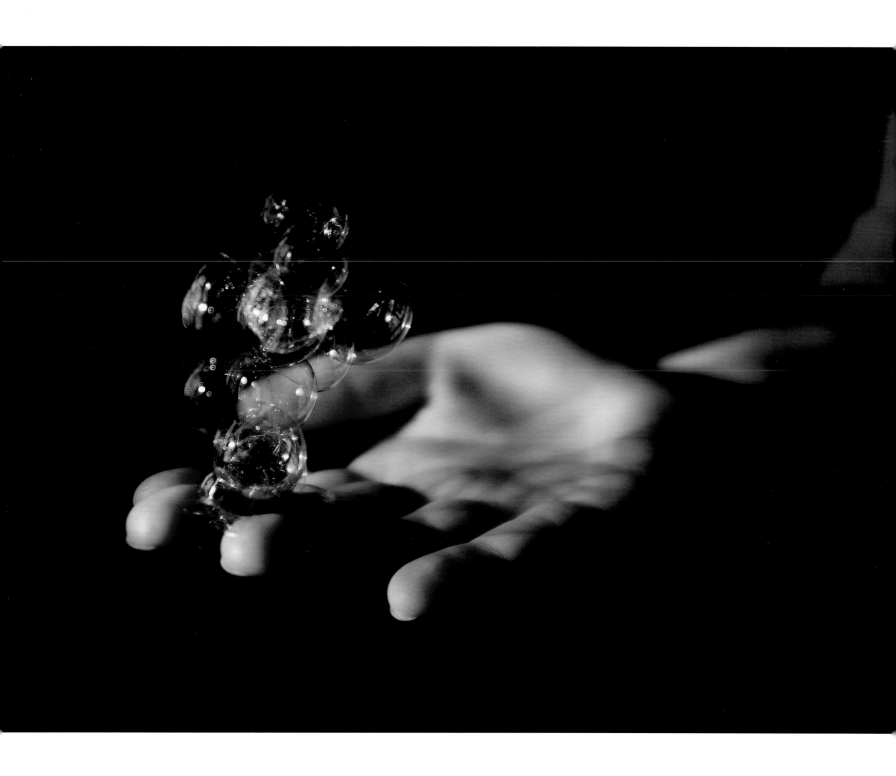

Maury Gortemiller, *Bubbles* (2015)

Ode to Silence MEGAN SEXTON

Glory to the half rest, to the breath between
 the third and fourth beats,
 the dwindling arrow of the decrescendo,

to the sunrise over Malibu, and its sleeping starlets,
 the empty horizon,
 the city's great thought still looming,

to parked cars, the cold engine seconds before ignition
 dreaming of the road
 unwound and endless,

to the lull before ecstasy, the saint's vigil
 of the dark soul in suffering,
 the grip of the heart before release,

to the inaction of love before the reaction,
 of the hand before it reaches out,
 its sharp twitch of self-consciousness,

to the embryo, the soft dream of the womb,
 the golden truth of genesis,
 the sustained hush and its amplitude.

H. Gay Allen, *Delta Mud* (2013)

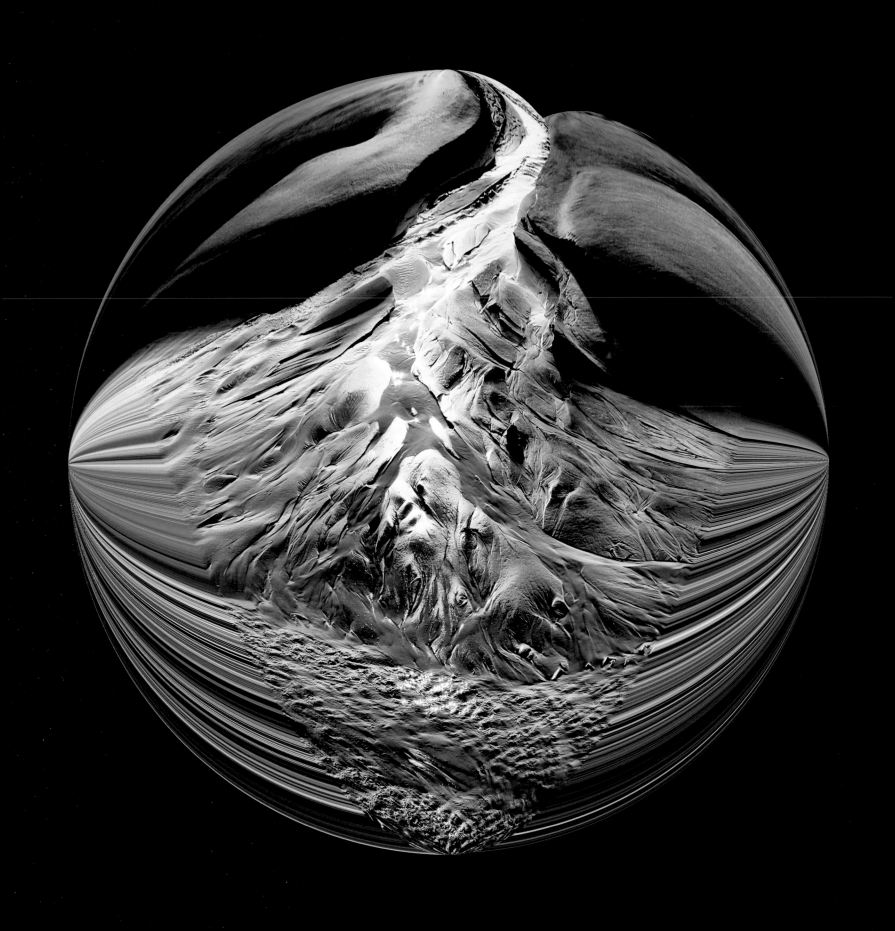

Credo ANDREW ZAWACKI

You say wind is only wind
& carries nothing nervous
in its teeth.
 I do not believe it.

I have seen leaves desist
 from moving
although the branches
 move, & I
believe a cyclone has secrets
the weather is ignorant of.
 I believe
in the violence of not knowing.

I've seen a river lose its course
& join itself again,
 watched it court
a stream & coax the stream
into its current,

 & I have seen
rivers, not unlike
 you, that failed to find
their way back.
 I believe the rapport
between water & sand, the advent
from mirror to face.

 I believe in rain
to cover what mourns,

 in hail that revives
& sleet that erodes, believe
whatever falls
 is a figure of rain

& now I believe in torrents that take
everything down with them.

The sky calls it quits,
 or so I believe,
when air, or earth, or air
has had enough.

 I believe in disquiet,
the pressure it plies, believe a cloud
to govern the limits of night.

 I say I,
but little is left to say it, much less
mean it—
 & yet I do.

 Let there be
no mistake:
 I do not believe
things are reborn in fire.
They're consumed by fire

& the fire has a life of its own.

Ars Poetica BETH GYLYS

I should go now beyond the barn
where inside, horses snort and mouth
strands of hay, beyond the fence line,
beside which tall thin weeds barely peek
above the snowbank, where I'll sink
to my thighs, where the field lies
covered and white and gentle,
and it is quiet as death. Further back,
where the treeline begins and the land
drops down, the creek's still moving,
its lining of fallen leaves not quite frozen,
its movement sending steam into the still
and frigid air. If I crouch there
on top of the snow, my knees
sunk, blue jeans into whiteness, will I know?
If I take off my gloves and thrust
my hands into the water, will I know?
I should go further than the stream
back into the woods, where the snow
is shallower, but blown in piles
against the tree trunks. I should try
to stop shaking. I should remember
the barn, the warm moist nostrils of the horses.
I should press on until nothing
looks familiar, but all is similar: thin
trunks of trees and beneath them
the snow making miniature landscapes
of hills and valleys, a whistling
from somewhere, and cold, a little
bit frightened, I should stop again
and listen again, until I start to know.

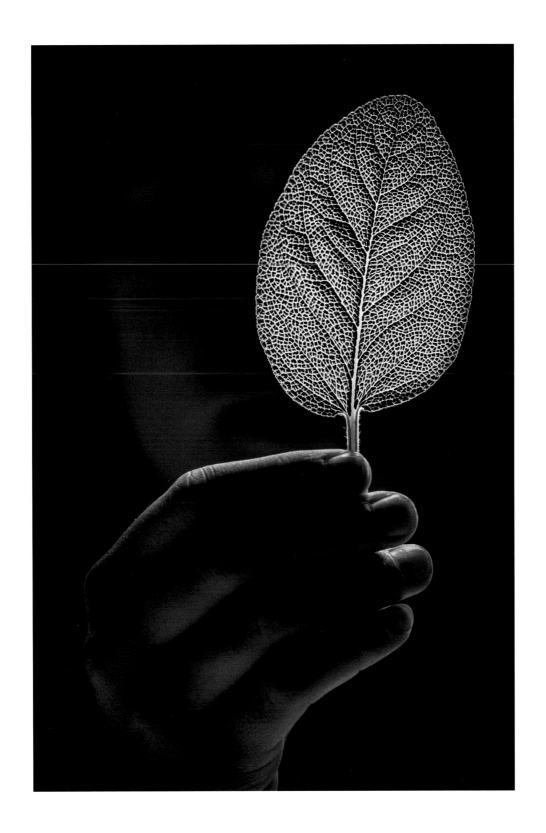

Mark Caceres, *Sage* (2014)

Tracing Back ALICE FRIMAN

In the history of reading,
there's many a cracked heart,
lost letter, stopped clock, cut wrist.
Any cursory push through poems
or stories and you could trip
over the drownings
or the heap of crushed
petticoats fluttering on the tracks.

To the bookish, I say *careful*.
What's between two covers
can creep beneath covers.
Any thief worth his prize
knows how seduction works:
ingratiation: the innocent pull
of words, that belly crawl
of language. What do you
think that first slither was
coiling the winesap,
so lovely, our girl was forced
to write it down, there
on the underside of leaves.
Hers, to sneak past the terrible
gates, hidden in the rustle
of her figgy apron: the key
to what she didn't know yet
but would be looking for
in all her troubled incarnations.

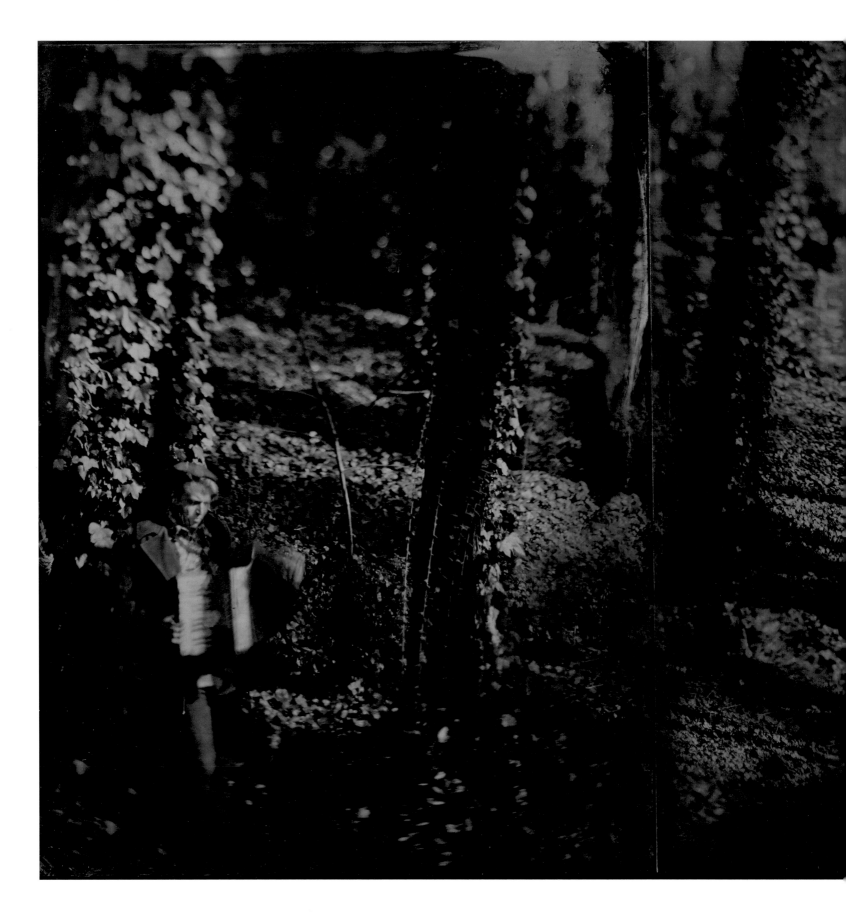

Mary Anne Mitchell, *Play On* (2015)

Rylan Steele, *Desk, Columbus, Georgia* (2015)

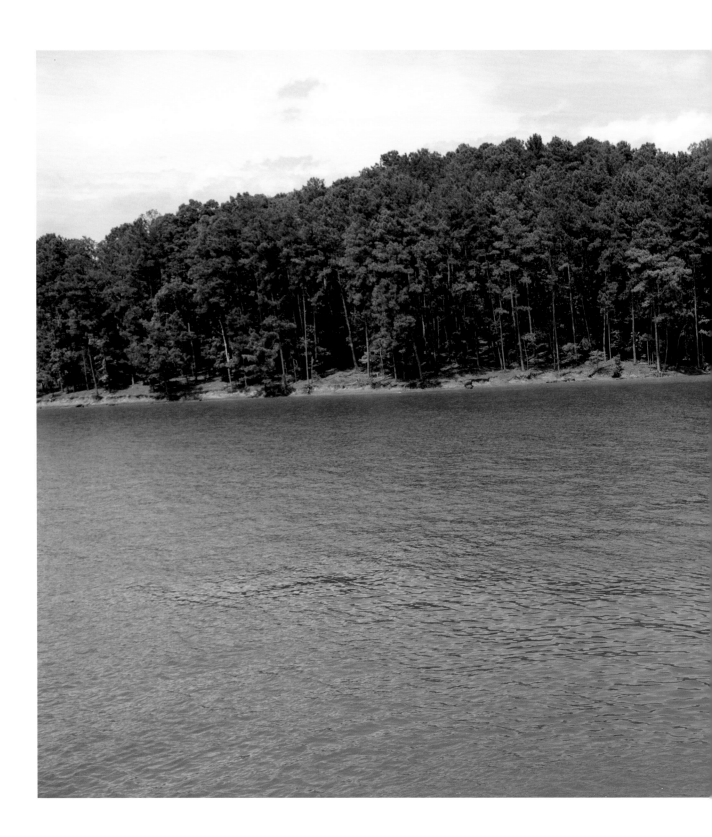

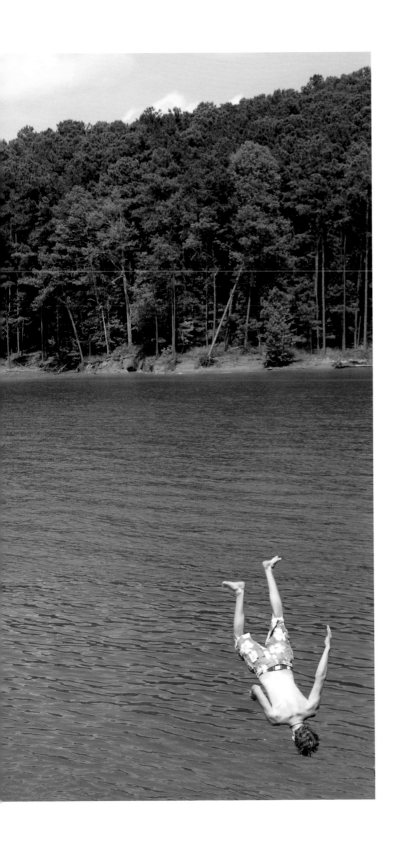

Joeff Davis, *Acworth, Georgia* (2014) 19

Hummingbird Sleep COLEMAN BARKS

A hummingbird sleeps among the wonders.
Close to dark, he settles on a roosting limb
and lowers his body temperature
to within a few degrees of the air's own.

As the bird descends into torpor,
he assumes his heroic sleep posture,
head back, tilted beak pointing to the sky,
angling steep, Quixotic, Crimean.

This noctivation, the ornithologist word for it,
is very like what bears do through the winter.
Hummingbirds live the deep drop every night.
You can yell in his face and shake the branch.

Nothing. Gone. Where? What does he dream of?
He dreams he is the great air itself, the substance
he swims in every day, and the rising light
coming back to be his astonishing body.

Judy Lampert, *Red Shed near Bostwick, Georgia* (2007) Harriet Dye, *Azaleas Through Spanish Moss* (2013)

24 Erin Mazzei, *Untitled* (2013)

Wind Event SANDRA MEEK

Sky through the sweetgum's limbs, powder-blue stasis, thrummed
light: no tornado-heralding downshift

to ivory plum, asparagus cream, the wounded grass of picnics'

deciduous families. No siren: just church bells
marking the hour, silver iced-tea spoons

clattering crystal, fluted clouds
of stirred sugar and lemon; a bird's

tight trill—spine

of a chant, a wing bone's
whistling tunnel: what isn't there, what makes

for flight, the cavity of shadows

hidden in heartwood, the trunk's
detonation to one-hundred-foot tumble

of green light, no

rotation of air, no bullet-spiral just
boom and crack and an arc

of glossed leaves, a shimmering tremor stilling
its veil of dust: ballast and sail—

Ballast, and sail.

History of Rain JUDSON MITCHAM

What if every prayer for rain brought it down?
What if prayer made drunks quit the bars, numbers hit,
the right girl smile, shirts tumble from the dryer
fully ironed? What if God

required no more than a word? Every spot
of cancer would dissolve like peppermint,
every heart pump blood through arteries as clean
as drinking straws then. All grief would be gone,

all reverence and wonder. But if rain
should fall only once in a thousand years, rare
as a comet; if, for fifty generations,
there was never that sweet hint of metal in the air

until late one April afternoon
when the dust began to swirl above the ball field,
and the first big drops fell, popping in the dirt,
and sudden as a thought, great gray-white sheets

steamed on the asphalt, fought with the pines,
would we all not walk out trying to believe
our place in the history of rain? We'd be there
for the shining of the world:

the weeds made gaudy with the quicksilver breeze;
the rainbows floating over black-glass streets;
each cupped thing bright with its blessing; and long
afterwards, a noise like praise, the rain

still falling in the trees.

Ben Lee, *If I Forget Thee, Cripple Thy Hand* (2015)

John Sumner, *Fair, Gay, GA* (1981)

There Were Some Summers THOMAS LUX

There were some summers
like this: The blue barn steaming,
some cowbirds dozing with their heads
on each other's shoulders, the electric fences
humming low in the mid-August heat. . . .
So calm the slow sweat existing
in half-fictive memory: a boy
wandering from house, to hayloft, to coop,
past a dump where a saddle rots
on a sawhorse, through the still forest
of a cornfield, to a pasture talking to himself
or the bored, baleful Holsteins nodding
beneath the round shade of catalpa, the boy
walking his trail toward the brook
in a deep but mediocre gully,
through skunk cabbage and popweed,
down sandbanks (a descending
quarter-acre Sahara), the boy wandering,
thinking nothing, thinking: Sweatbox,
sweatbox, the boy on his way
toward a minnow whose slight beard
tells the subtleties of the current, holding there,
in water cold enough to break your ankles.

Ken Callaway, *Along Dry Creek* (2010)

Taylor Bareford, *The Easter Egg Hunt* (2014)

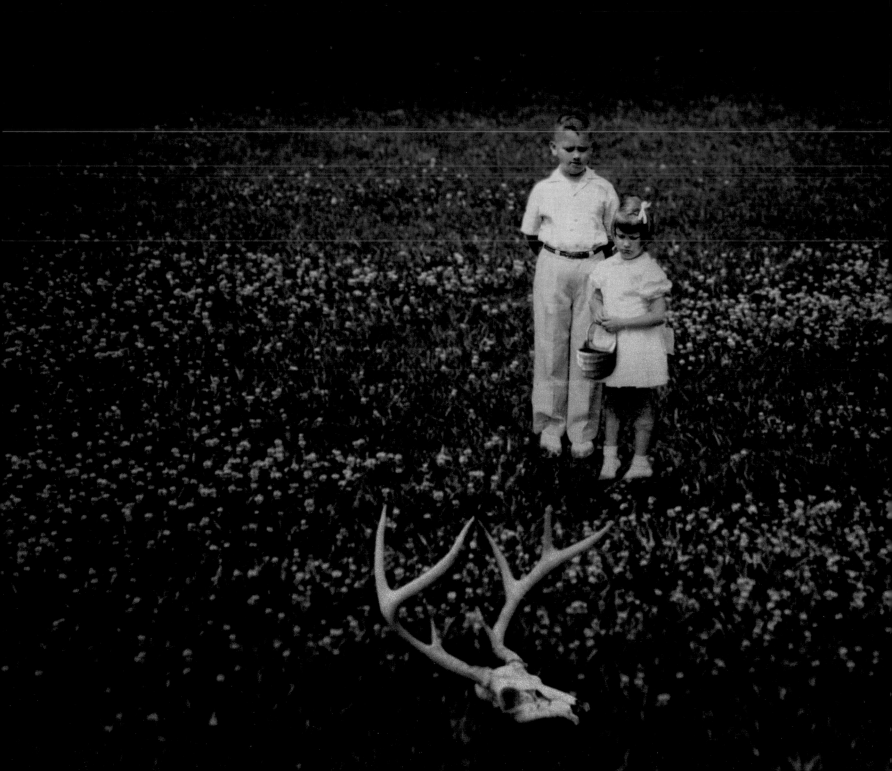

Waiting in the Dark JANISSE RAY

Some nights when news is bad in the world
we go out and look at the sky,
which is dark even before the work day ends
save for pinpoints of stars and sometimes
an ivory disk sailing across it
over the shoulder of Wantastiquet.
The garden has disappeared under a trace of frost,
and Ezekiel Goodband's barn is filled
with heirloom apples. The yellow haze of maples
has faded, and the last of the leaves have fallen
like old newspaper and been swept up.

Come, darkness, with your longing.
Come with your rags and your death.
No one faults you the lies, the deceit.
You were meant for rest and sleep.

At solstice we will build a bonfire
on a hillside, a friend's field, beyond
greenhouse and pen, to watch the wine-moon
rise over the horizon like a chariot drawn
by dark horses. The moon will come close,
bright and orange as a winter squash, traveling
the long night. We will run up the hill to greet it.
The children will wave their little flags.
Remember how Mars one autumn
hovered as close to Earth as it had
in sixty thousand years, then drifted away?
These are the last days of the leaving.
We have entered the coming back.

Tom Meiss, *Impaired Vision* (2010)

Fence R.T. SMITH

Not because it is the thorn vine that renders no fruit

Not because it divides the forbidden zone from the tame

Not because it is the measure of a man's mission
To limit and to own

Not because it is the harp wind will never
Fret to harmony

Not even because it links the soaked posts
As the imagination makes myths of the stars

But because a sick calf in July
Will scratch her black hide on a barb
And leave one snagged tuft
And the suggestion of relief

And because the oak will accommodate it
And will sequester a section that rusts with sap and gall
Through the years and their issue

And because it will not follow the stream in flood,
The bee in hunger, the crow, the marmot, the shrew

And because it will never satisfy the transit,
Its precise azimuth

Because it is the sentry
It is the tether,
The necklace of possession

It arrives in bales
It is unwieldy It needs the torture of stretching
It shines

And because it awards blisters to the palms
And cuts the careless arm
And collapses on no schedule
And can be resurrected
And is a kind of harp after all
That knows the one note in the snarl of storm
And trembles in tune with the nerve
Running deep in the heart of the reluctant tongue

And because it gives birth to the gate

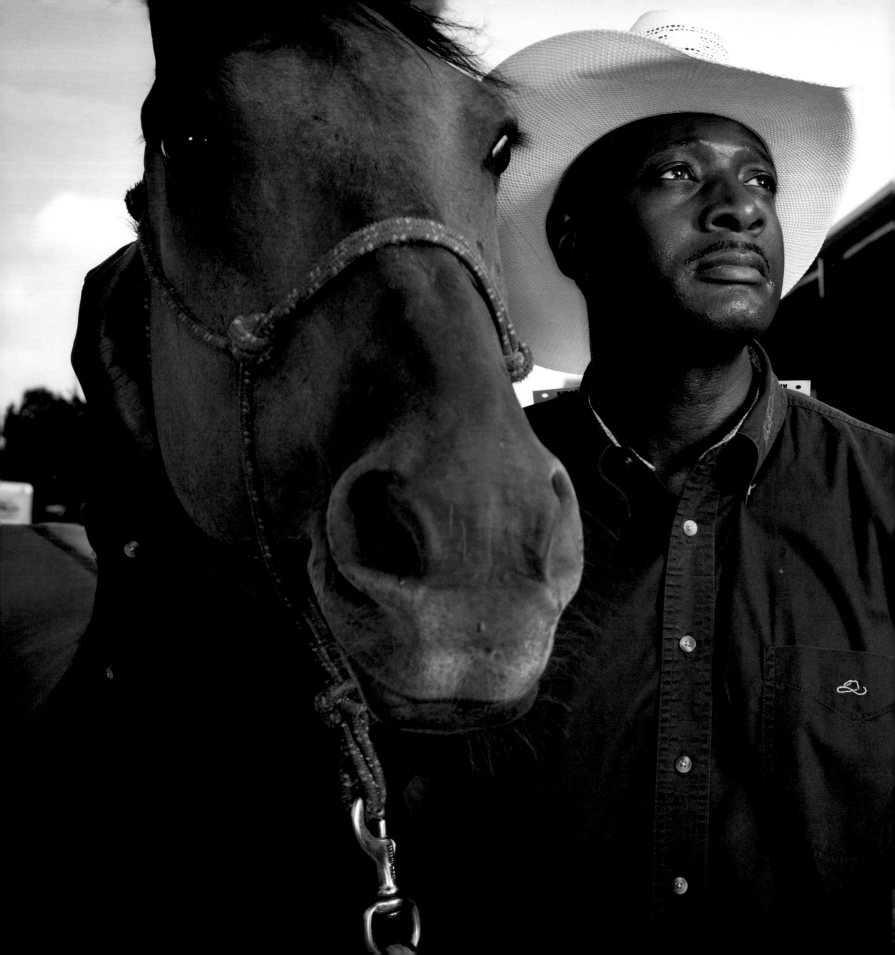

Forest McMullin, *Derry L. Pierce* (2014)

Diamonds KATHRYN STRIPLING BYER

This, he said, giving the hickory leaf
to me. *Because I am poor.*
And he lifted my hand to his lips,
kissed the fingers that might have worn
gold rings if he had inherited

bottomland, not this
impossible rock where the eagles soared
after the long rains were over. He stood
in the wet grass, his open hands empty,
his pockets turned inside out.

Queen of the Meadow, he teased me
and bowed like a gentleman.
I licked the diamonds off the green
tongue of the leaf, wanting only
that he fill his hands with my hair.

Caitlin Peterson, *Stone Mountain* (2012)

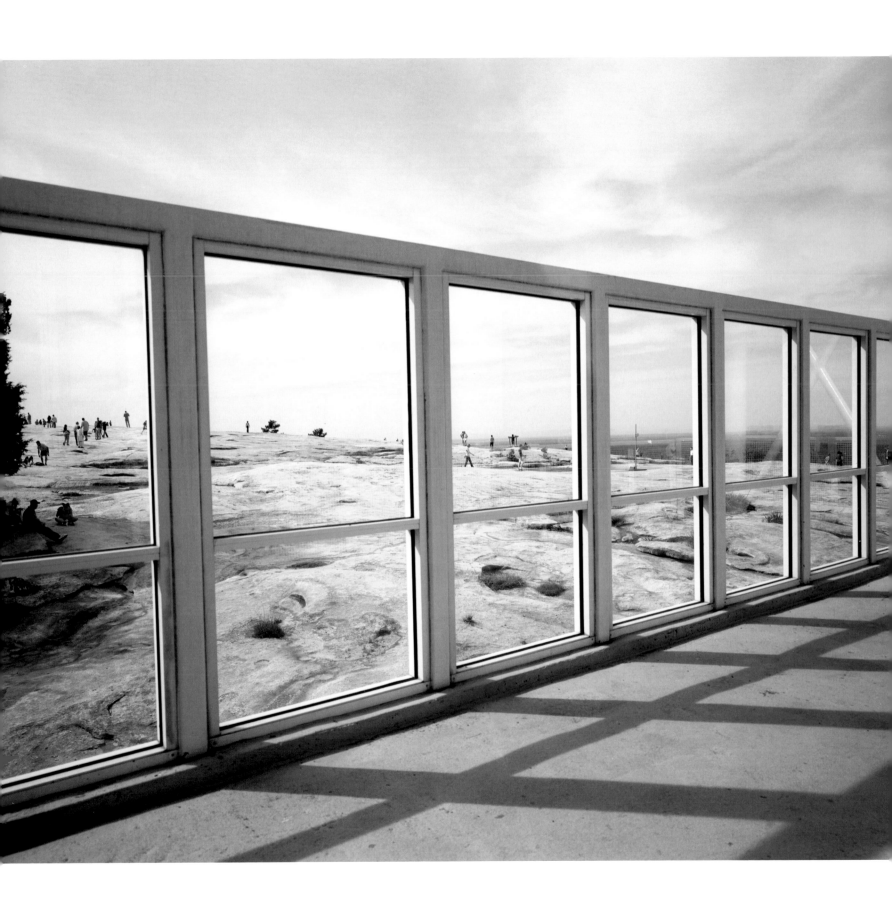

Hit the Road Jack OPAL MOORE

I keep a grand piano
in the living room,
glossy black baby grand
single wing lifting
in a flight of silence.

mama bought a spinet used
for me, her musical mute,
a secret tithing for a piano player
genius child touched by god
to sing her soul's secret song.

women slyly accused her
of pretentions *unchristian*,
of chicken wing dinners, gizzards and beaks,
the poverty of pride unseemly—
the men watched her hips.

she saved these betrayals
in white glove perfections,
in silent kitchens pulsed
with the rhythm of cake batter beaten
with a spoon,
in the brown tips of crisp lemon pies
egg whites whipped
to a froth with an angry fork
for sundays.

she believed in music,
in piano's gleaming whiteblack civilization,
in children's souls,
in god of creation,
in gentleness.

she saved the tears for the dark-paned night,
for radio music ungodly, for ray charles:
hit the road jack and don't chu come back
no more no more no more no more...

I overheard her in the Saturday night,
startled her kitchen face wet with betrayals,
kissed her young mouth grim determined

learn to froth cool egg whites with a fork,
touch my fingers to the keys
of this grand machine that no one plays,
its great wing lifted
in prayer to whiteblack gods
flat fingered mute
magical.

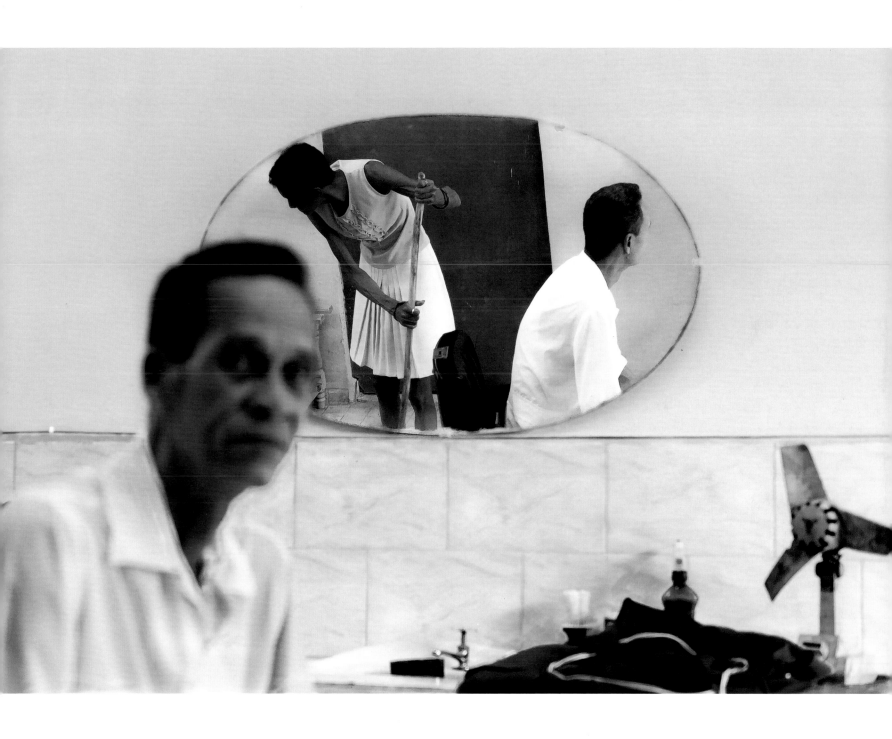

Jamie Maciuszek, *Cleaning Up* (2012)

Apartment on 22nd St. ALFRED CORN

for Darragh Park

Because dusk comes in not long
after five o'clock in Chelsea
and lamps wake to life, a gold
wash falling from them,
resting on the blue-and-white,
lighting small gold clouds
in the dark wood,
or pooling in circles on the carpet;
and presumable cars whisper by
as curling leaves rattle at
the windowsill and the late hour
settles in deeper, in tune,
it could be said, with Delius on FM;
and facts, severe but familiar,
adhere to velvet, to polish, glass
and silver, and to pictures of things.
Or because calm, the readable
representation of calm, is
an achieved thing, like the last
fine overlay of glaze or light;
and because, finally, one is
entitled to a signature, affixed
now much like a reliable fact,
briskly drawn, streamlined like the city—
the painter nods and lays down his brush.

The Closing STEPHEN BLUESTONE

There's much to do before we have this house,
before we settle down with it long term.
The double casements crack to winter drafts,
the inside walls are wavy like old glass,
thin flat-head nails hold down the splintered slats,
and the leaking kitchen's lined with broken boards,
with lathing strips and rotted tongue-and-groove.
We'll make it ours unless a workman's torch,
removing paint, kindles the parchment attic,
bringing fiery witness in through the overhang,
exposing secrets that it wants to keep.
Before we own it clear and call it ours,
this house will want to know just who we are.
We pause from time to time to say our names.

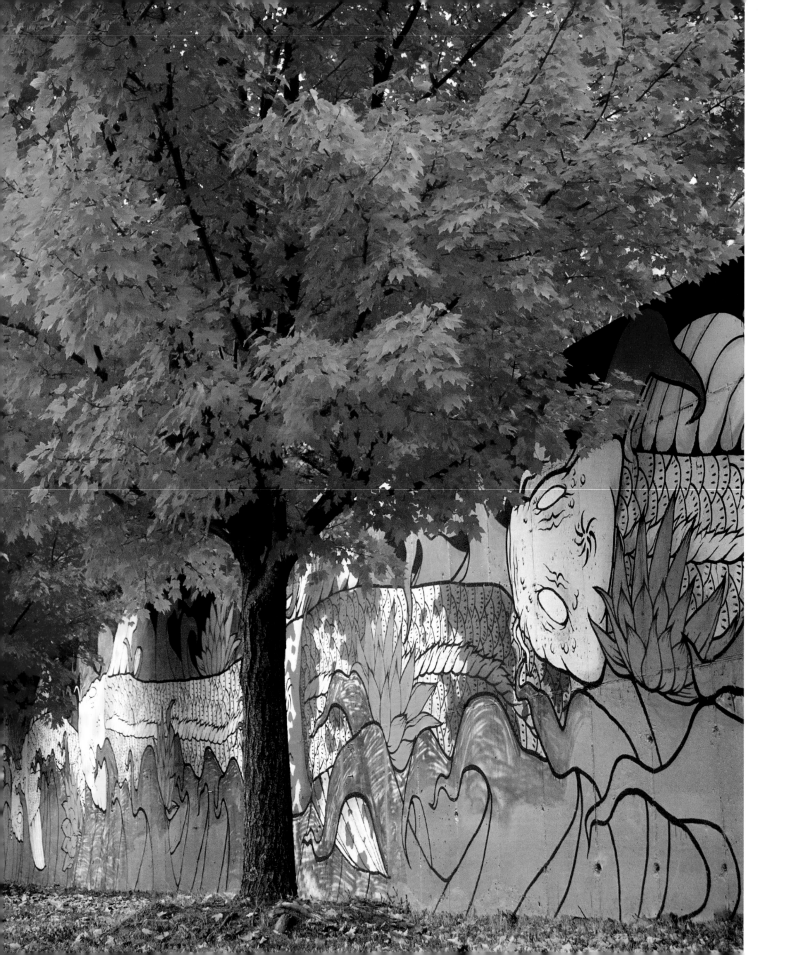

Off Broadway GREGORY FRASER

I loved a woman who cherished orchids less
than weeds, gray-headed dandelions running off
with the wind to seed. Adoring what let her in,
as I did not, she suspected the concave-convex
manner of the sea: blue invitations offered
then withdrawn. I still turn corners in cities
we tramped—Kyoto, Edinburgh—hoping to crash
in her hair. With a single lesson, like a cloud,
her hair could speak the native wind (scirocco,
breeze-over-the-dale) wherever our loved grants
landed us. If only our shadows, one long afternoon,
could cross in a truce without our knowing.
Somewhere off Broadway make it, near the first apartment
we rented, for what seems now like next to nothing.

Linda Coatsworth, *Irwin Street Mural* (2011)

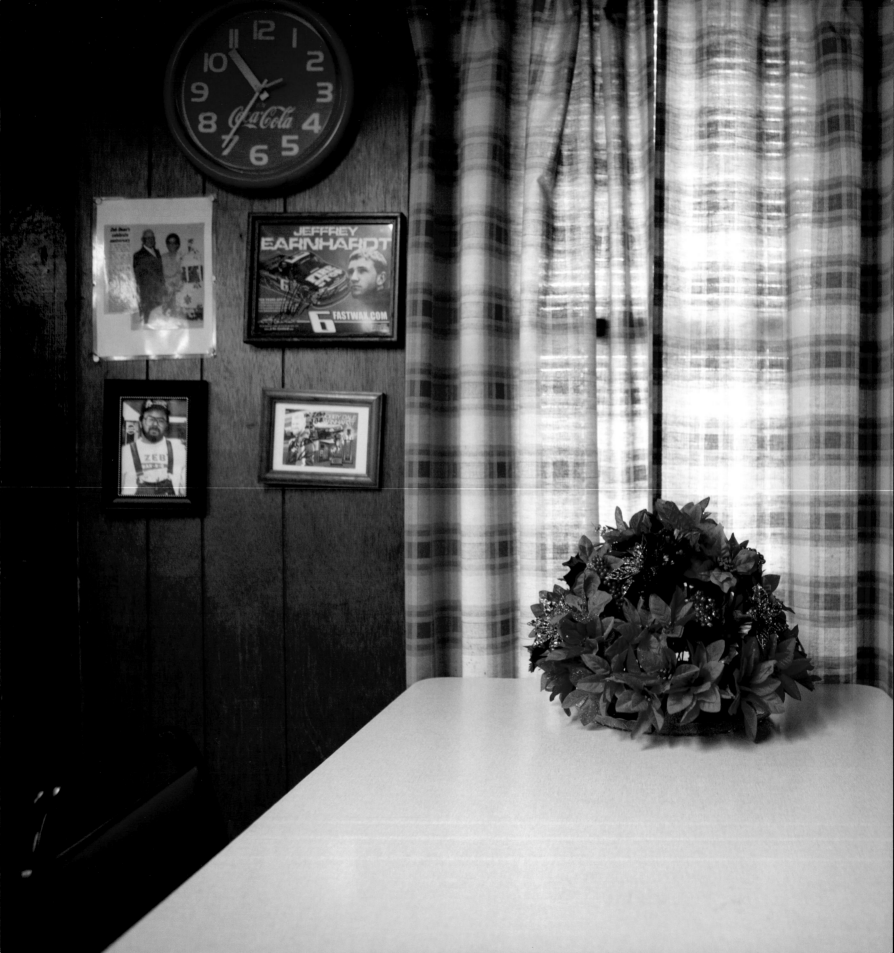

Amanda Greene, *Zeb's* (2014)

Michael Reese, *Joseph* (1996)

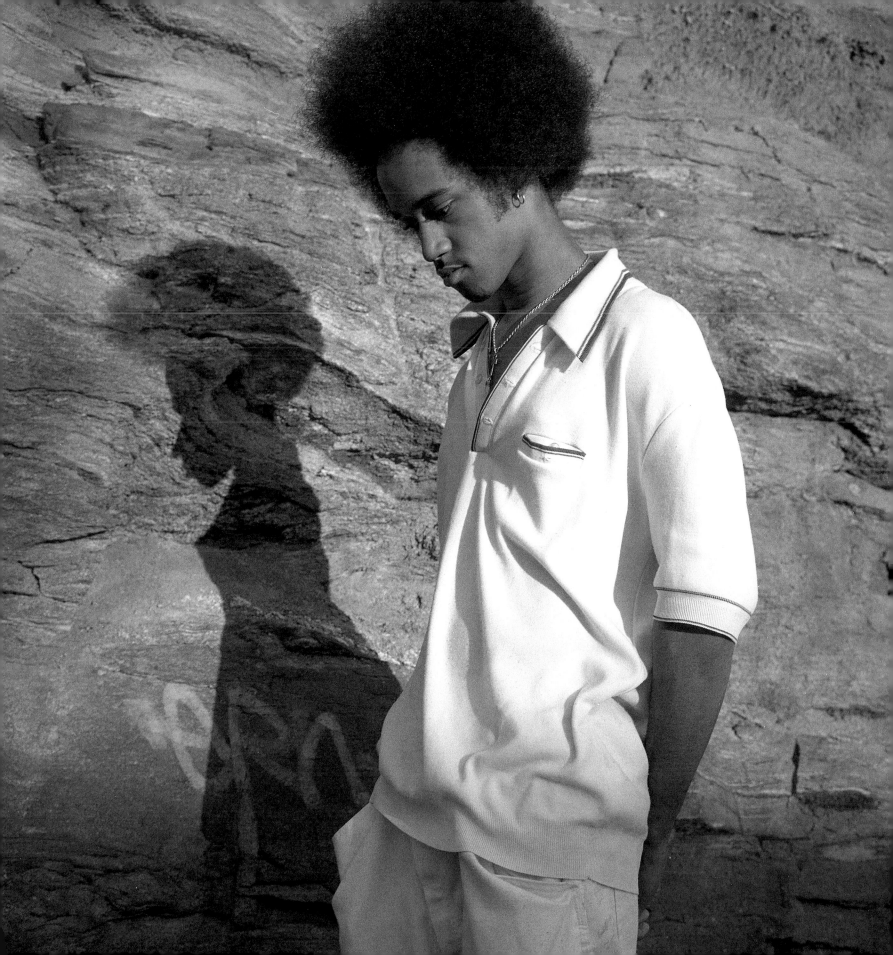

Women of America CHARLIE SMITH

On the pale morning I left town
I was thinking about women,
and later, in the Rockies where work was scarce,
I thought of women all day
and pretended I was in Florida, for example,
at the little business opportunity my friend Calico
ran in the mall at Perry. By roads in the desert
and among the bean fields in California
I thought of women and
preserved this huge interior life for them
like an estate sheltered from creditors.
It was better, like Dante, to have the woman
out of sight, to spend my time thinking about her,
like Petrarch, like the crippled Leopardi, Keats
and all the rest, to save myself the trouble of real life
and the provincialisms of fact, all that,
the women somewhere maybe in heaven
or upstate New York, doing something
besides thinking of me, I didn't mind,
the conversation went on anyway, its riches sustained me,
the complex multifactors crossing
and intermixing like a high school band
in its difficult formations. Everything else
was simple gesturing, an arm reaching out a car window
to hand someone a sandwich. Of what this came to,
I can't really speak, the women
in their trials and compacts, their anguished disputes
outside small-town jails, of these
I have nothing to say. I was seized by thought,
on a pale morning in Alabama,
distracted as I pumped gasoline, wondering
about Hazel and the grip
she still had on me—How so, Hazel, I thought
and thus time began to pass, in America.

Sleeping on the North Rim RON SMITH

We had driven ourselves
all that way to be alone, start over.

Now she wanted to talk. She talked,

but the wind wanted me to lie down and sleep.
She blocked out part of the sky.

Yes, I said, I am listening.

The curve of her cheek: starlight.
Her words: rain that never reached the river.

That was silence, that steady hum

of the engine swallowing blacktop,
that vibration in the body like utter fatigue,

and the earth giving way,

breaking its vow, falling
into the long obscure story of its youth. Yes,

oh yes, I am, I said, and I was.

Lucinda Bunnen, *Shrouded Figure* (1989)

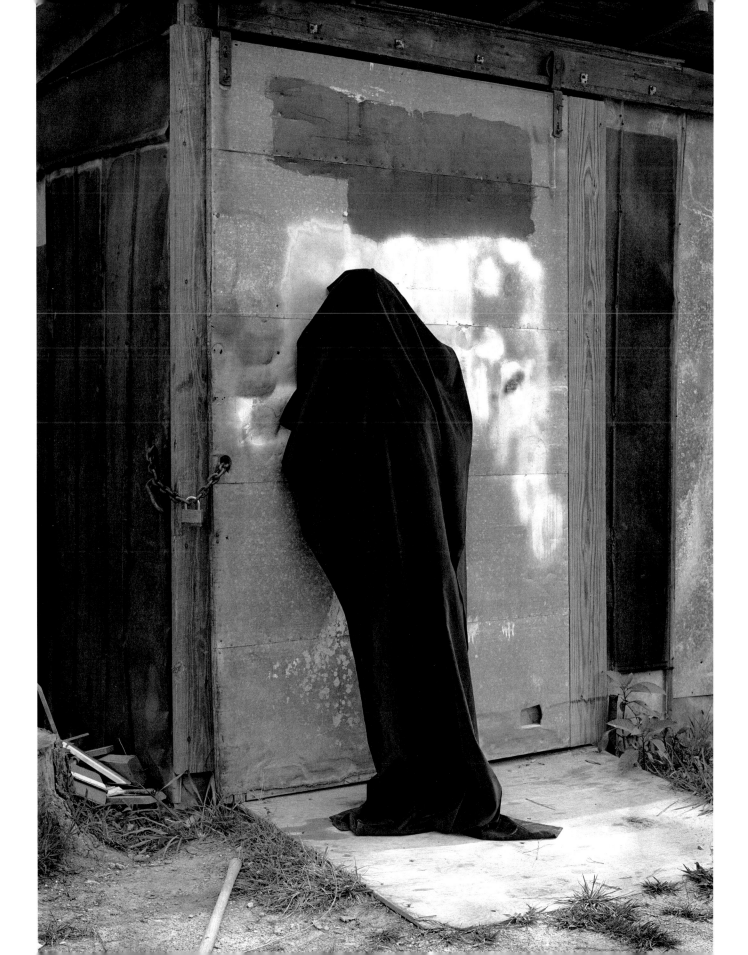

Folk Lore KELLY WHIDDON

In a house on water, she remembers
dances at the American Legion,
Chantilly Lace and the boy in the band
who was married but not happy.

Fire crackles between breaths,
echoes to the cathedral ceiling,
shimmers in the mahogany
dining table. And she tells of days
her father jumped on the back of a fish truck,
threw out dinner for their mother to catch,
came home and waltzed her
around the room.

We watch ripples beneath the steam and early
morning fishermen.
"We were hungry," she says.

In Ravenna CHAD DAVIDSON

Three boys, old enough to hurt someone,
young enough to think it doesn't matter,
sat outside the small green plot I came to.
Dante's grave. All of us pulled there,
experiencing gravity, out of control
for different reasons. I could not prepare,
really, for facing this, just as these boys—
smoking too deliberately, collars relieved
like rose petals from the extravagant
ceilings of basilicas—could not understand
their own indifference, or why they huddled,
stared when I walked by. They were a type
of beauty, as far as beauty is ignorant of itself,
disdainful of place: that casual square,
Franciscan façade, that entire city turning
under the swelter of an afternoon, June
in the marshlands to the east. Sometimes,
I stand in front of history and feel nothing.
Then, some wrecked mosaic, awkward
in the transom of a secondary church, behaves
just so, as if the artists thought of me and all
my imperfections. Sometimes, people gather
in the hearts of forgotten cities, and I hate them
for their nonchalance, the terror in their boredom.
They have been dying here for millennia, these boys,
and there is little I can do, on this casual trip
in the heat, map in hand, to guide them out.

My Lovely Assistant PATRICK PHILLIPS

After the episode of *That's Incredible!*
in which a whole family of Armenians
in sequined shirts ate fire
and spewed blue, burning plumes, my brother
tied a cottonball to a bent coathanger
and dipped the end in gasoline.

What made us who we are,
one crazy, fearless—one always afraid?
I stood by the ping-pong table
in our mother's only sparkly dress,
playing the role of *Patricia, Lovely Assistant*

because he was bigger than me,
and a master of the headlock,
and threatened, with his breath of snot
and bubble gum and cigarettes,
a vicious wedgy if I didn't.

So l handed him the silver Zippo,
not knowing what future waited for my brother,
still thinking I could save him
who hated being saved—

who took my dare one night to lie
on the yellow stripe of Brown's Bridge Road
and stayed there talking to himself,
pointing to a satellite adrift among the stars,
while I begged him to get up.

Who sat in an upstairs bedroom
giggling at the click of our father's .38.
Who loved the sting of the torch
sizzling his spit-glazed tongue.

So I kept one eye on the door, knowing
from experience how it would end,
how all things turned finally to anger
in that house, where he leaned back, shark-eyed,
and took a swig from the red gas can,
the spitting image of our father in a rage.

He stood between me and that pain.
Knowingly, he raised the magic wand up to his lips.
I sit and wonder what it means—
my brother's sweet face
bursting into flames.

The Real World is Like This: ESTHER LEE

My sister's bed's a bird's nest, all edges,
construction paper. She keeps adding
what she coaxes father to give up
before the police arrive: food stamps, silver
parts of a handgun. If she doesn't stop, her nest-bed will
soon be too wide to fit through
any doorframe, let alone down the hallway.
Our mother turned hummingbird (predictable
as it is), her blurred form and curled feet
hidden in the closet. Along the way my sister
and I misplace our mother's bird-throat and mistake
her silence for fatigue.

To make noise I wear
tap shoes, to school, *click-click*
over ice and tile and with each click, my sister grows
away from me. I stare down at my silver shoes,
toward what my mouth can't afford.
My sister, on the other hand, looks up
at the stretched net overhead. She figures
an escape. *Through that empty patch*, she tells me,
pointing at the tiniest square of sky.

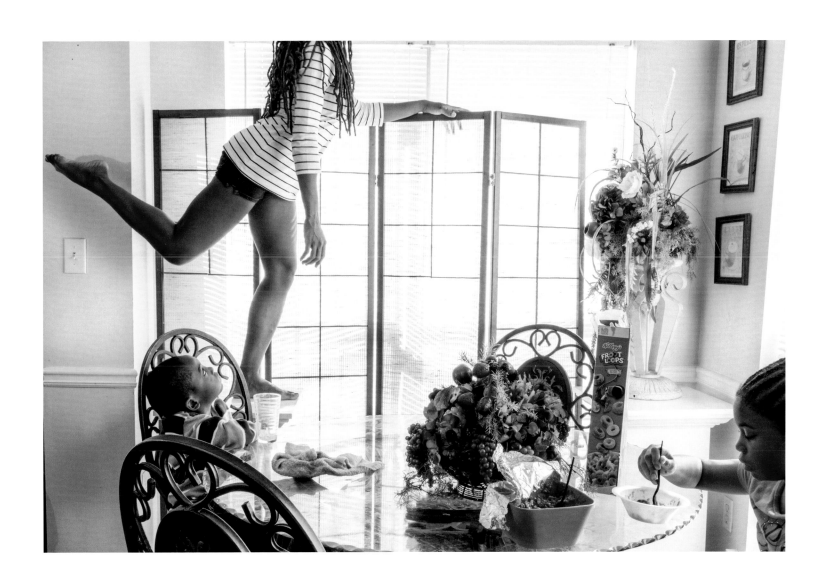

Shoccara Marcus, *His curiosity, my mission, trio* (2014)

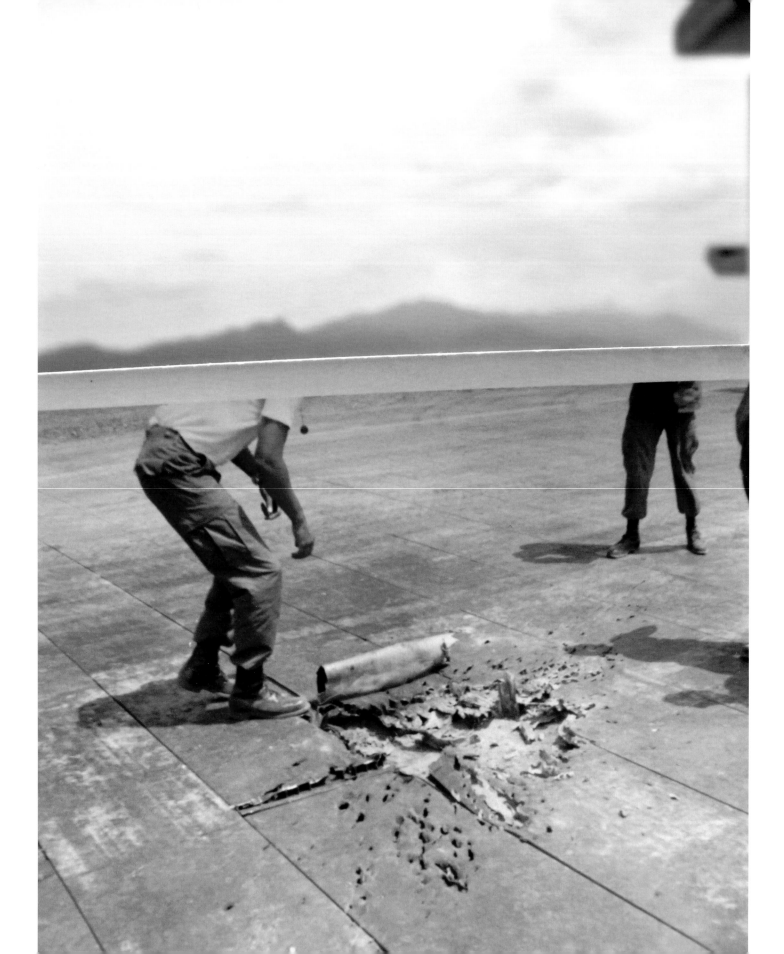

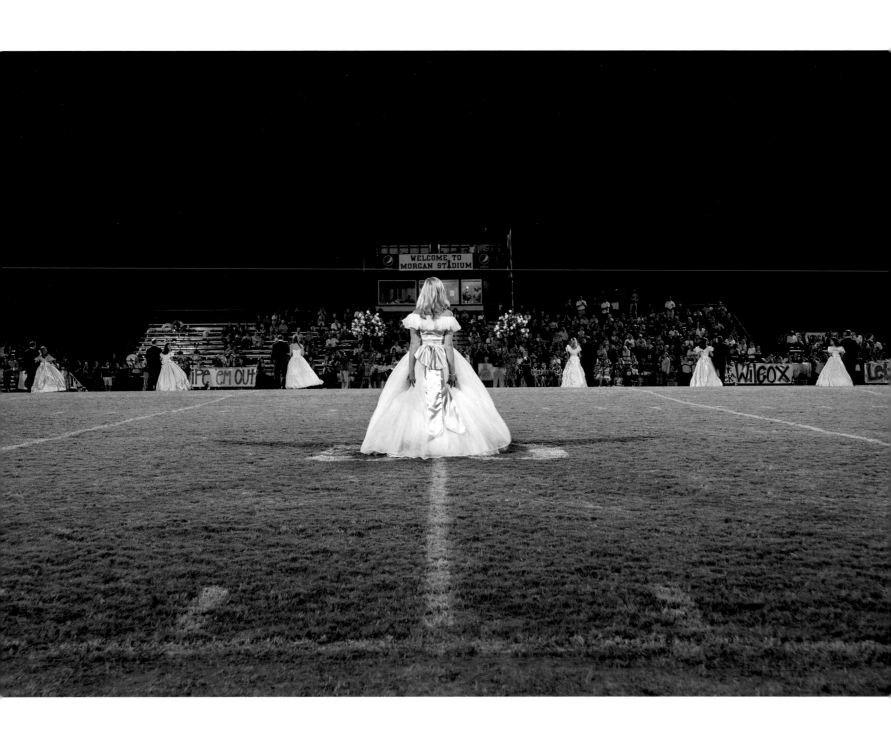

Jerry Siegel, *Homecoming* (2009)

Georgia Landscapes DIANE KIRKLAND

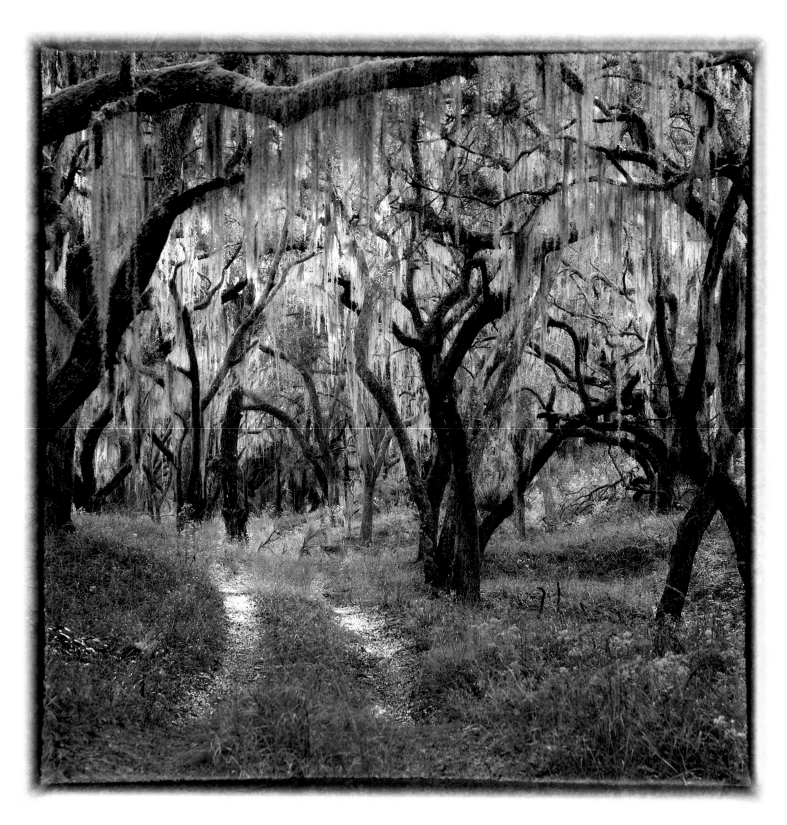

Diane Kirkland, *Forest Road*

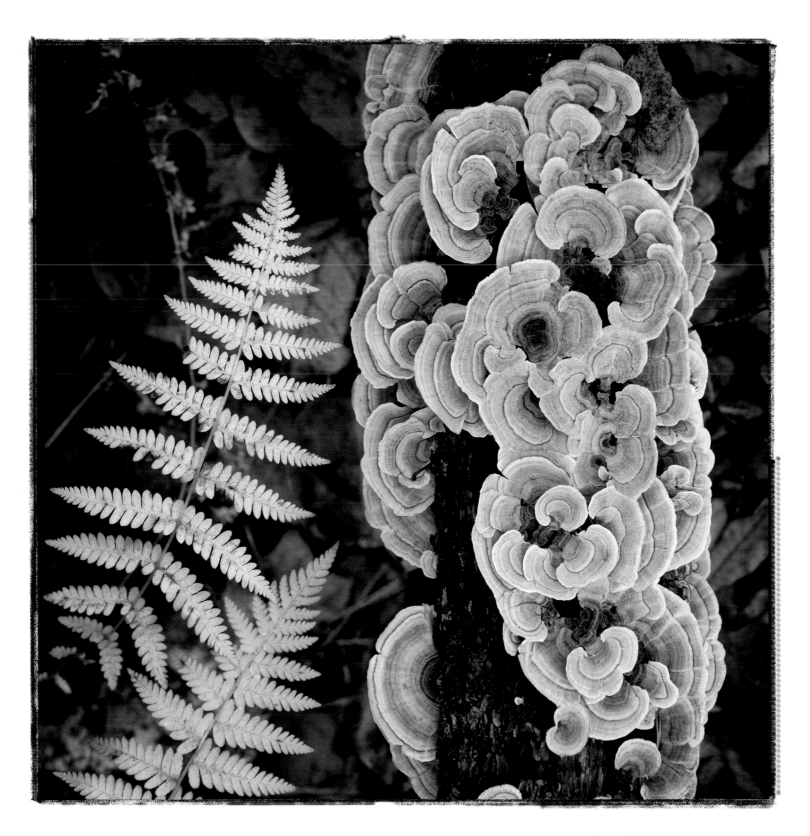

Diane Kirkland, *Fungus*

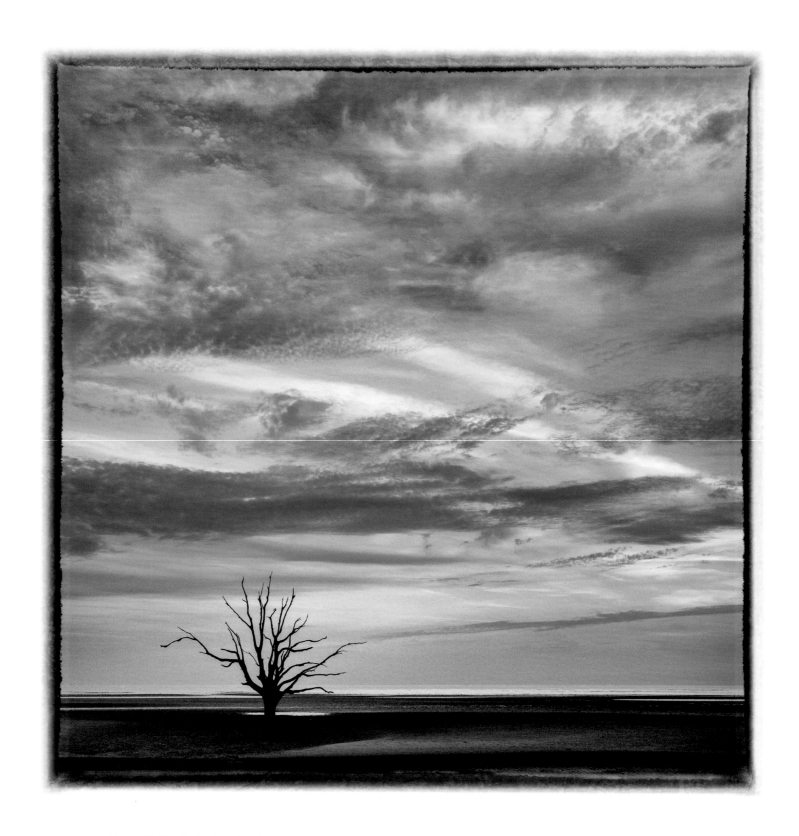

Diane Kirkland, *Ossabaw Beach*

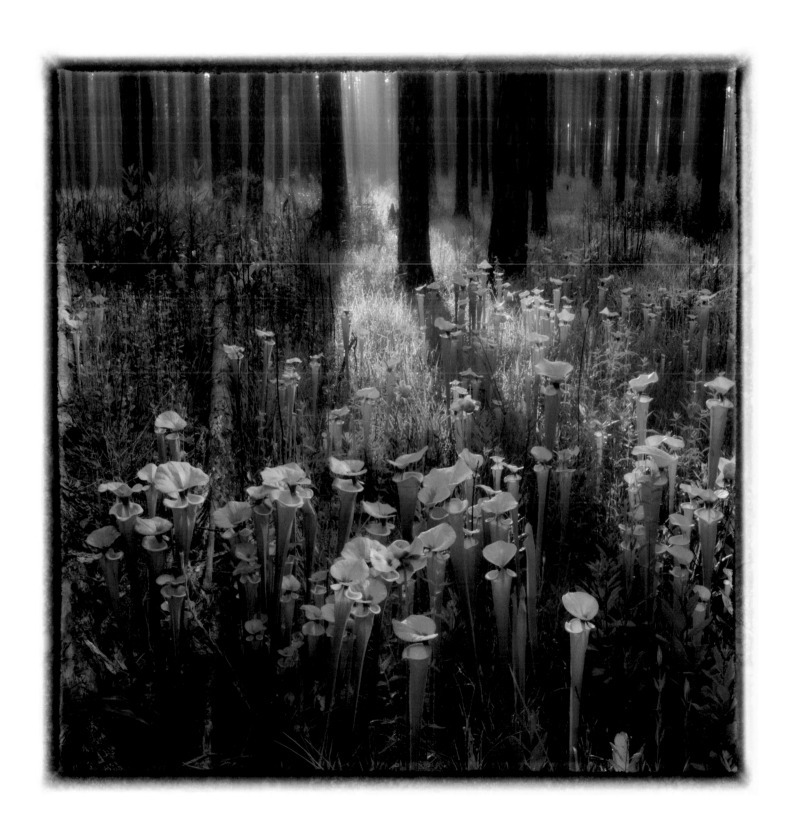

Diane Kirkland, *Pitchers*

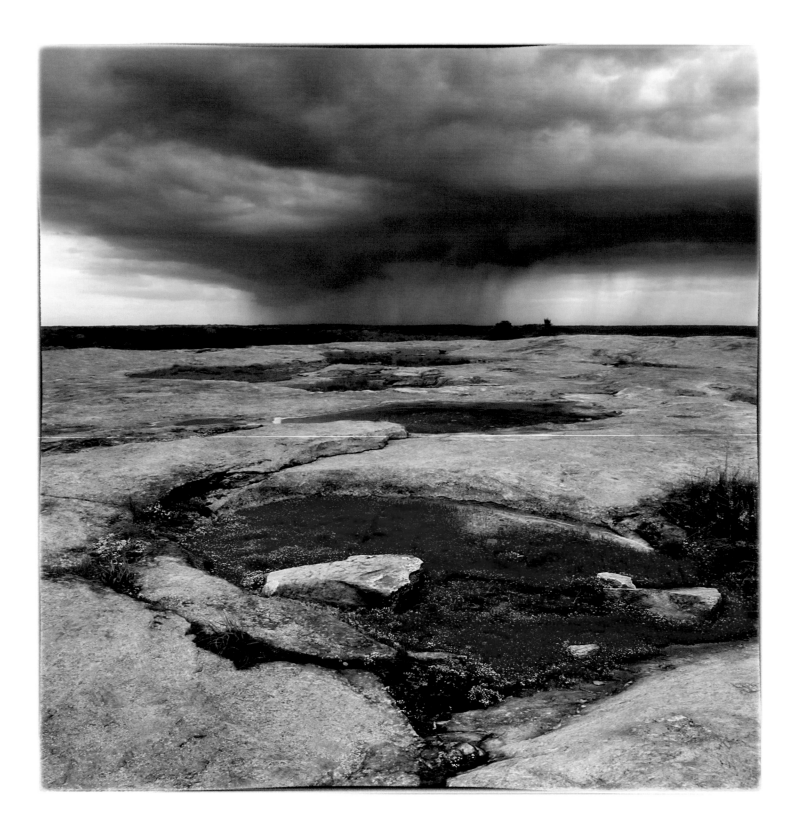

Diane Kirkland, *Mt. Arabia*

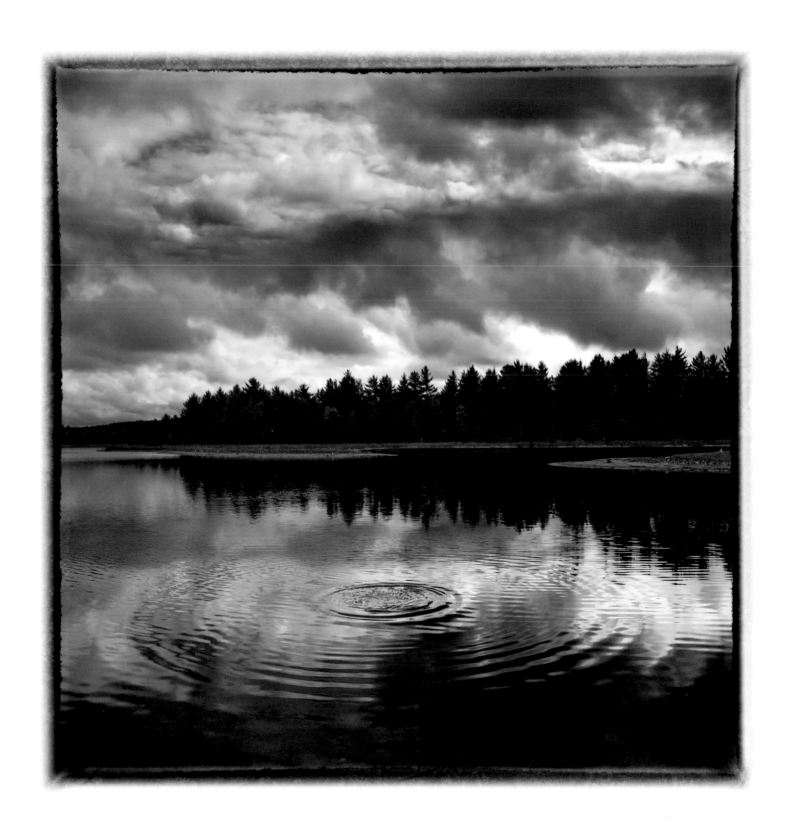

Diane Kirkland, *Lake Burton*

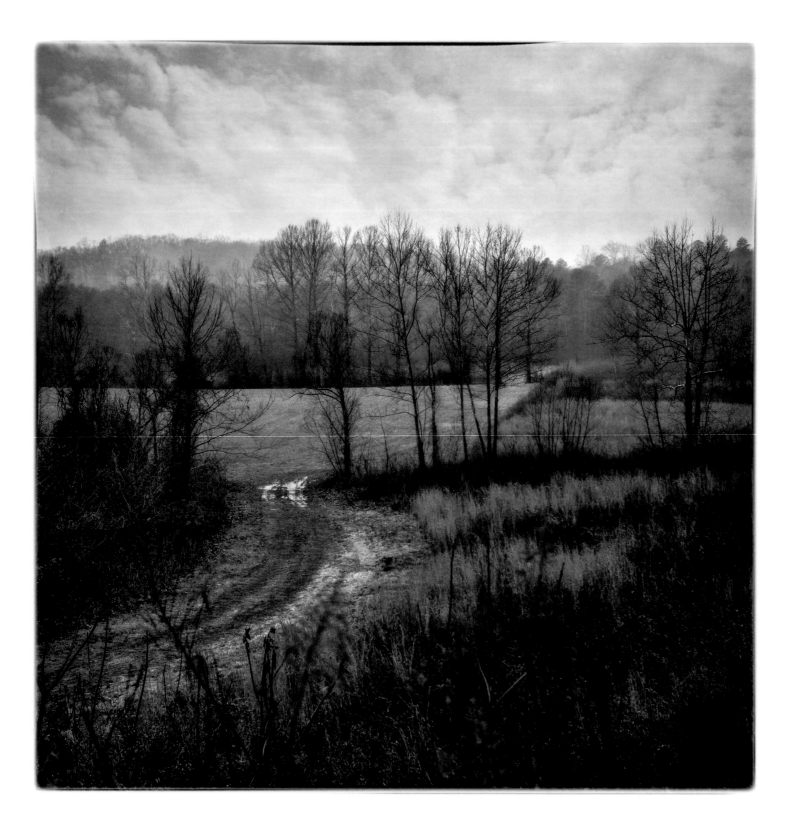

Diane Kirkland, *Canada Creek*

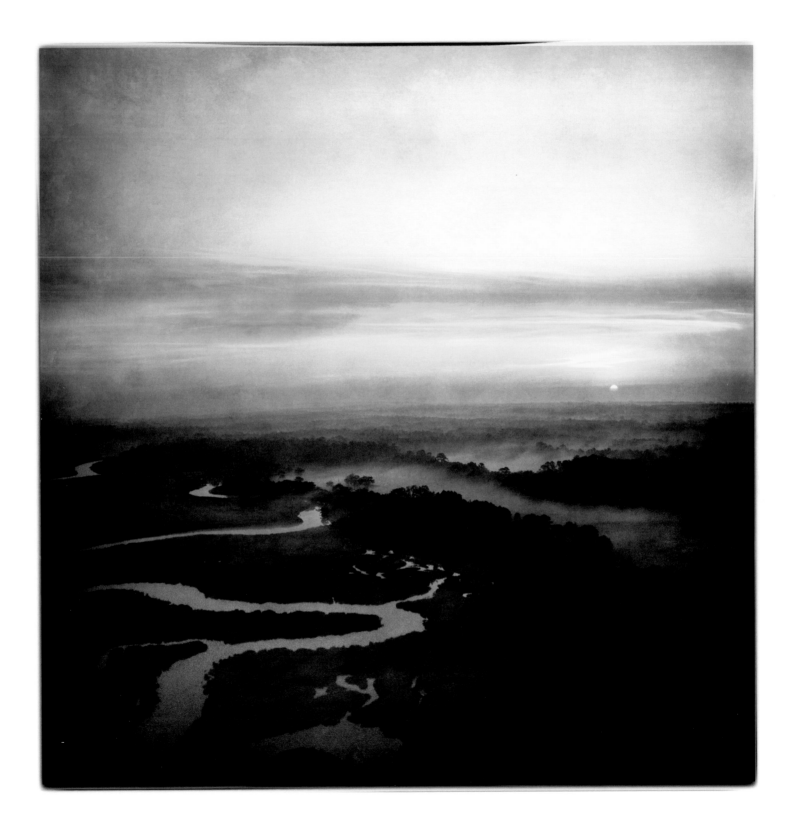

Diane Kirkland, *Sapelo*

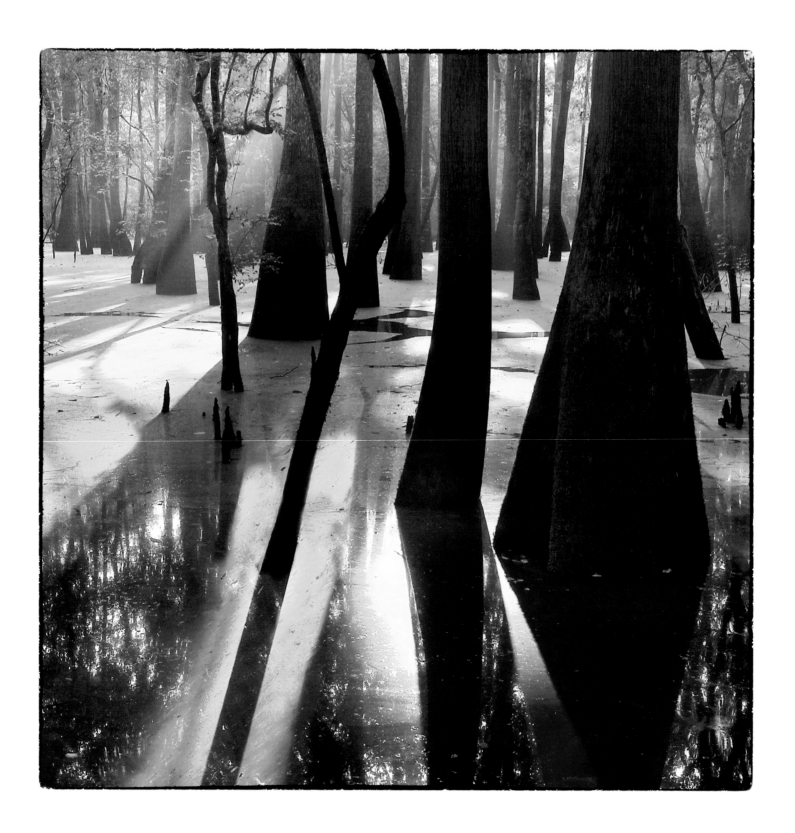

Diane Kirkland, *Moody Swamp*

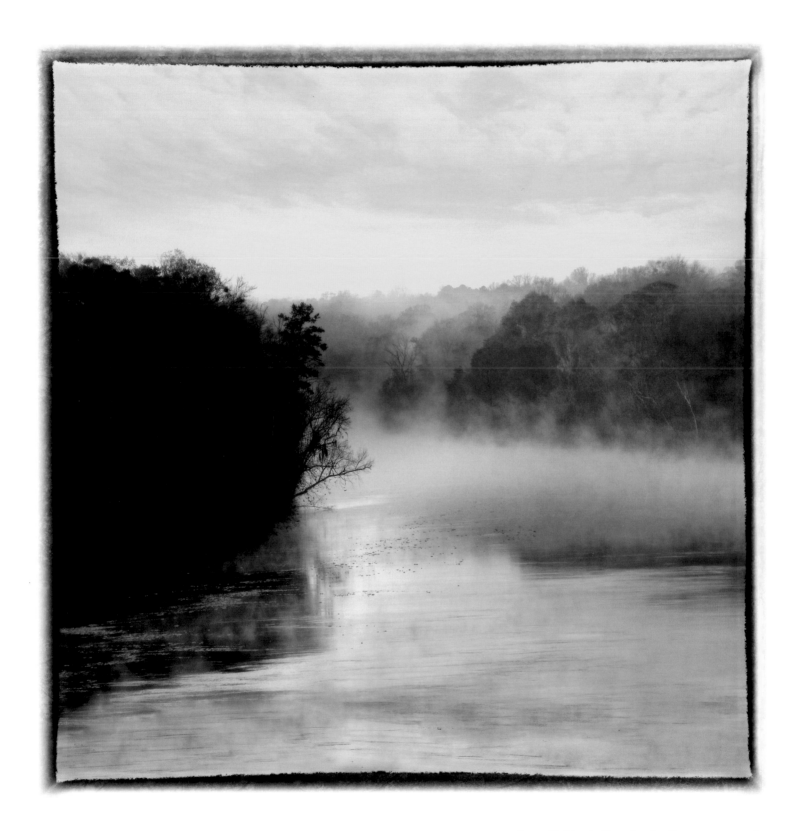

Diane Kirkland, *Chattahoochee River*

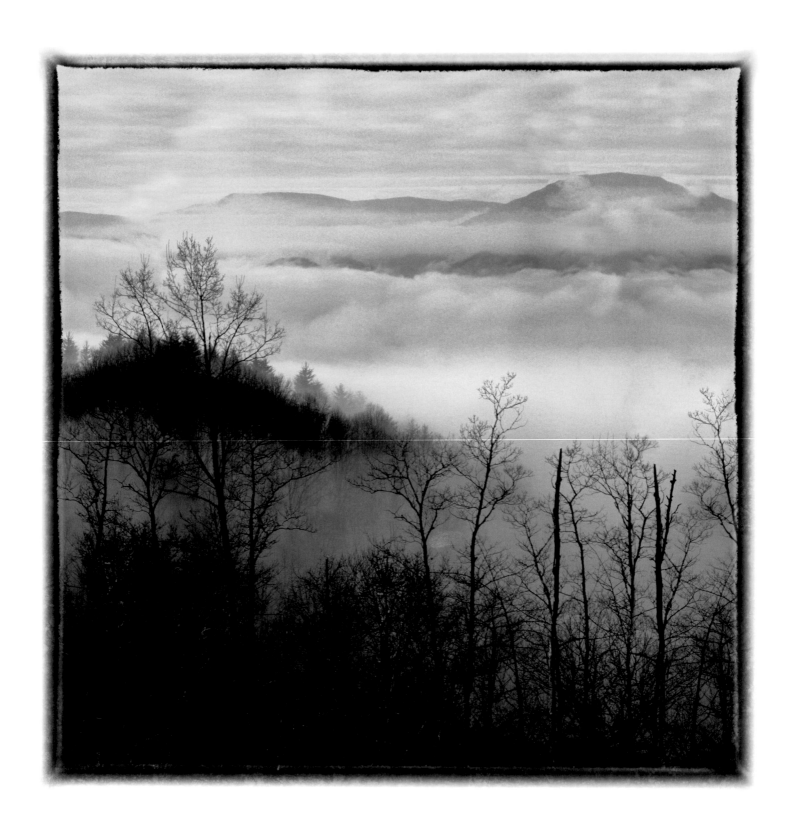

Diane Kirkland, *Mountain Fog*

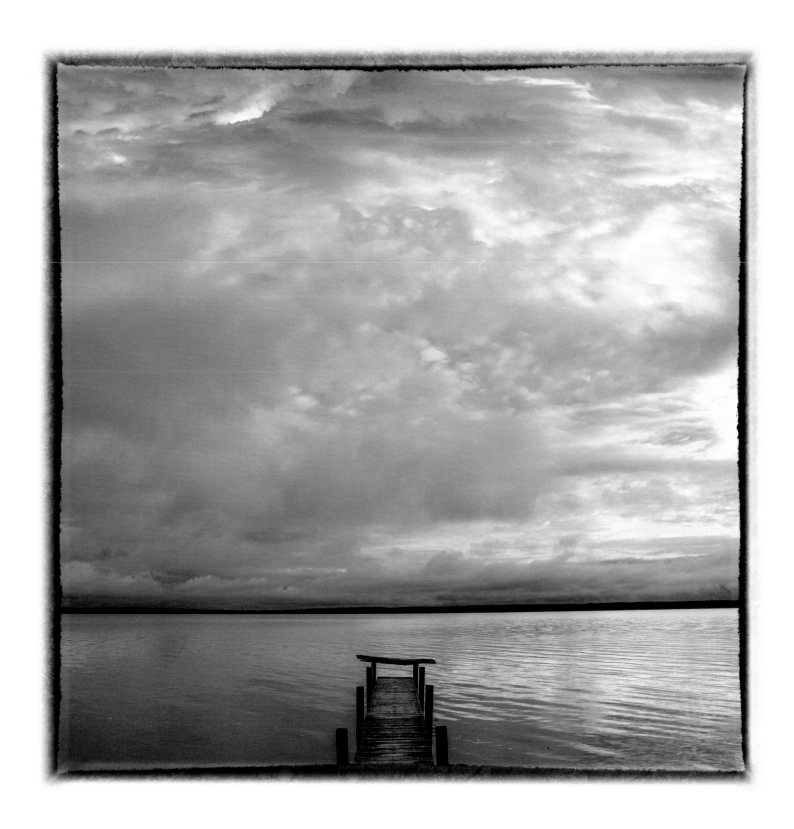

Diane Kirkland, *Sammy's Dock* 83

Quilts STEPHEN COREY

One woman wept, they say,
when a peddler reached her cabin
with no new patterns to sell.

Irish Chain, Persian Pear, Rose of Tennessee

I still make my bed with *Kansas Troubles*—
I was only five when mother said
"Twelve you must have in your hope chest, before
the Bridal Quilt, and that before you'll wed."
First my stitches tried to mirror hers,
our hands touching as we worked.
At night she plucked mine out
to keep her project whole.
Next came simple sewings: double lines
and scallops on my own crazy quilt.

Bear Track, Turkey Track, Beauty of Kaintuck

Some days, when Tommy and Jimmy ran outside
shouting off the chickens, I thought
I'd stretched myself across that frame, waiting
for the womenfolk to pad and quilt and bind me.
Yet with all the years of work,
when the time came Joseph had to wait
seven months while I finished *Jacob's Tears*.
The Bridal must be perfect, mother warned.
A broken thread a crop gone bad,
a twisted stitch a baby dead.

Wreath of Grapes, Flying Swallows, Pomegranate Tree

Sometimes our life is no more than the names we give:
Joseph moved us to Missouri,
and the women loved my *Jacob's Tears*—
but they knew it as *The Slave Chain*.
In the Texas flatland winds, *Texas Tears*
lay across the bed, and after the last move
we slept warm beneath *The Road to Kansas*.
That was many droughts and storms ago.
The colors still blaze enough to shame
a Puritan, and not a seam has given way.
Joseph is gone, but even coldest nights
my *Kansas Troubles* brings me through till dawn.

Meryl Truett, *Cotton Field with Shadow*

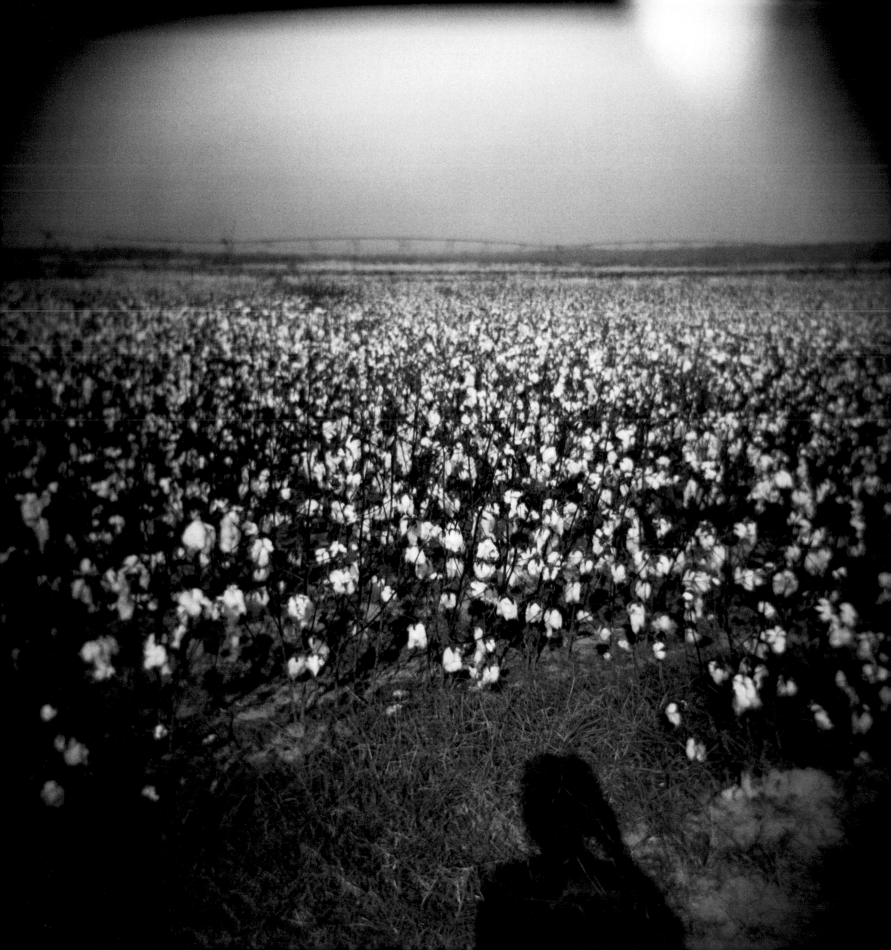

Matisse MEMYE CURTIS TUCKER

In the beginning, there was clutter, meaning women:
still life with objects on desk, still life with oranges—
in a dining room, pears strewn on the cloth,
decanters, bowls heaped with peaches, apples, a rounded
servant behind the table bringing flowers.

Even the nudes those years were knees, shoulders,
stomachs jutting past the chairs they reclined on.
Fullness. A plenitude of objects, the baby's
crib filling up. The hands of his subjects
disintegrated; his own grasped the studio table,
saying *mine*. A man who couldn't let go
of anything then, whose dreams gathered patterns, each
shape in its color, finally released his wife
by turning her into geometry: a silhouette
at a balcony saying *No*; an oval mask
wearing the feathered hat he loved.

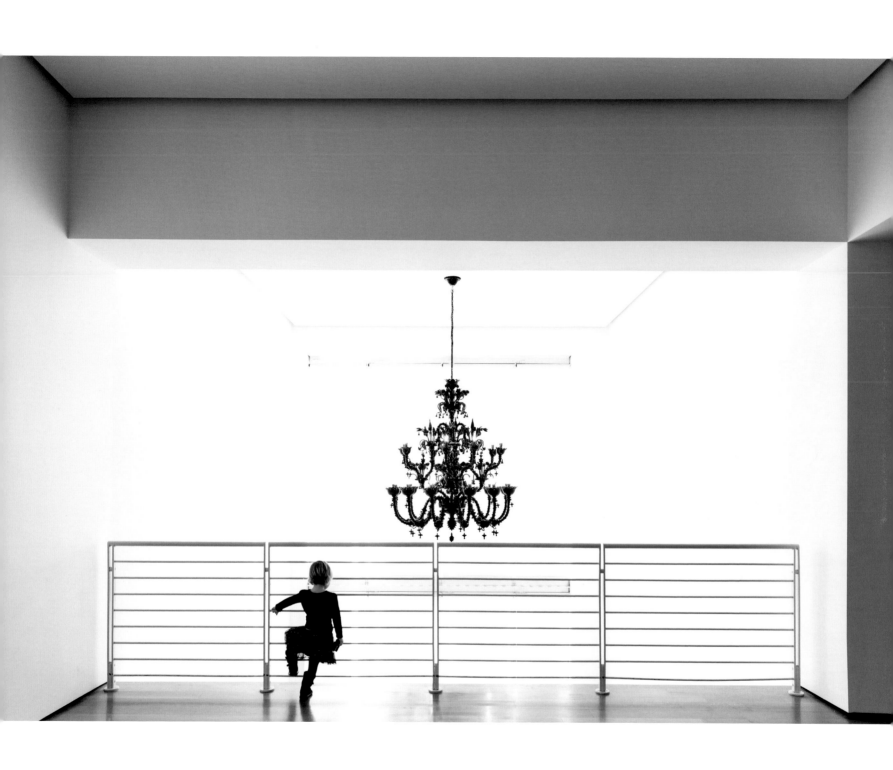

Jennifer Giliberto, *The View* (2015)

The Luncheon of the Boating Party LEON STOKESBURY

Under the red-and-white striped awning
extended over the restaurant porch,
the eyelids of these fourteen sundry revelers

seem to sag a bit, and that is because
by now they are all just a little drunk.
The party is as parties are. The people

are talking. Laughing. But in the upper
left-hand corner, a man wearing
a saffron straw hat, tilted jauntily down

over his brow, stands slightly apart
and silent against the thin balustrade.
This man stands with his back arched,

his chest out, and the large muscles
in his bare arms self-consciously flexed.
Certainly, he cannot be at ease, but then those

who desperately hope to be loved rarely are.
I say this because if one follows
the man's gaze across the top of the canvas,

across the party, to the upper right-hand corner,
one sees that he is, I believe, staring
at a young woman who has raised her hands

to adjust her hat or her hair, or to cover her ears
so as not to hear what the two men talking
to her are saying. The two men are smiling,

and one has taken the liberty of slipping
his arm round her waist. The young woman
is the only person in the boating party being

physically touched, and though she seems
oblivious to it, the man in the saffron hat
is not, and is not much amused by it either.

Then, as the eye roams over the rest
of the festive scene, the quiet joke of the artist
begins to emerge. For, although a half dozen

conversations continue on, half of these people
are not even seeing the person looking at them.
They are looking at somebody else. It is a sort

of visual quadrille, the theme of five hundred
French farces, except in this case the painter
must care very much for them all, for he has soothed

their wants and aches in a wash of softness.
I think he must have been a little drunk too.
But it is the eyes, these misty, wine-dark eyes

of the three women in the center of the painting,
that draw a viewer back again and again.
The women are looking at men. They are looking

that way women sometimes look
when they have had a little wine, and when
they are listening to someone in whose presence

they see no reason to be other than who they are,
someone to whom, as a matter of fact,
they wish to communicate how simple and gentle

life can sometimes be, how amniotic even,
as it seems to them now. It is not clear
if the men of the boating party perceive this,

or anything. To be honest, they seem selfish and vain.
But the artist sees it. And this is his gift,
this warm afternoon, his funny story to tell again

and again: a day of blue grapes and black wine, of tricks
of the eye, of the flow and lulls of time, and everything,
everything soaked in the light of sex and love and the sun.

Art ERIC NELSON

October, a woman and a boy, a tumor
overtaking his brain, draw pictures
in the waiting room.

She makes a red apple as round
as a face. Then from her hand a cloud
grows and darkens over the apple

until the crayon breaks inside
its wrapper and hangs like a snapped
neck from her bloodless fingertips.

He's drawn two stick-figures
up to their necks in falling gold
leaves, their heads all smiles.

It's you and daddy, he tells her.
Above them a flock of m's
fly toward a happy sun.

When she doesn't answer
he says on Halloween he'd like
to be a horse with orange wings.

Staring at his picture, she says
It looks like Thanksgiving.
Where are you?

He taps the sun, *I'm shining on you.*
She hugs him as if trying
to press him back inside her.

I'm not crying, she whispers.
He looks over her shoulder.
I'm not crying, too.

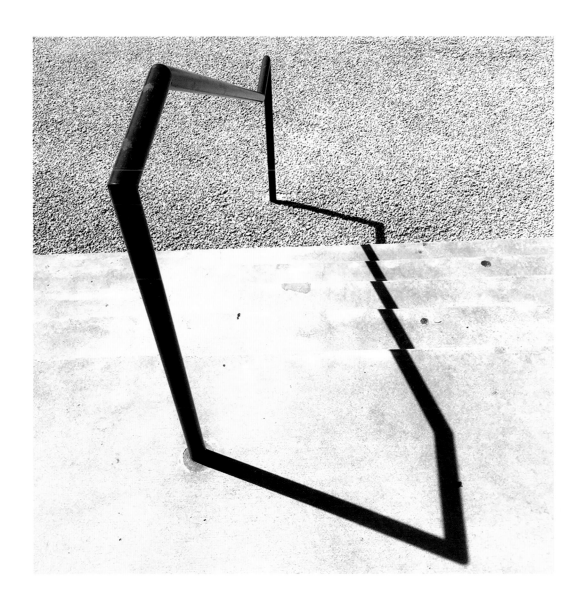

William Boling, *Untitled*

Spheres ED PAVLIC

after Monk

a brand burned into naked wood Property of PS 129
 an old-time upright wheeled out to the playground
 paradiddle & round the back hand clap

& tight coil rhythm bounce eyes closed smoke stained
 finger tips tangent to ivory sunshine in a wide-open mouth
 light poured like syrup fast twitch reflex & cold

 trust an amber lyric between blurry
 strangers

∽

a 3d compass swipe bloom & dance of exactitude
 theory & practice of minimal periphery chords aclang
 how to eat sounds with chopsticks echoes in a Spalding

deity of content criss-cross & nylon played out on bend words an orb
 cradled in a swan wrist a drop in the bucket wrist flick &
 arc Pivot & tango with gravity outside the

 fence fish out of water

∽

a calm afternoon sea dark with oblique sunrays
 a pack of bluefish & a school of herring frenzy & every
 splash aflame every ripple a molten

sneer gulls hover & dive seize specks of flesh
 & soar tiny drips of metal spin & fall
 into lighted crystal lips

 of the stone

‿

at 16 switch ends & talk the new
 stuff you follow if I trace a circle on the court say
 6 inches around

& now I trace the same circle circumference 6 on this here
 ball the radius on the ball is shorter like you
 shorter than the one on the ground

forget what he says check

‿

smooth creme & scarred-over broken scales back
 cuts & passes snap vector & no look witness to a path
 on the sharp rim of blueing optimal

route some say between A & B leaves no puncture
 no mark on the skin travels a surface of unlimited size
 pulse & translucent gourd to the

 smallest possible

 infinite space

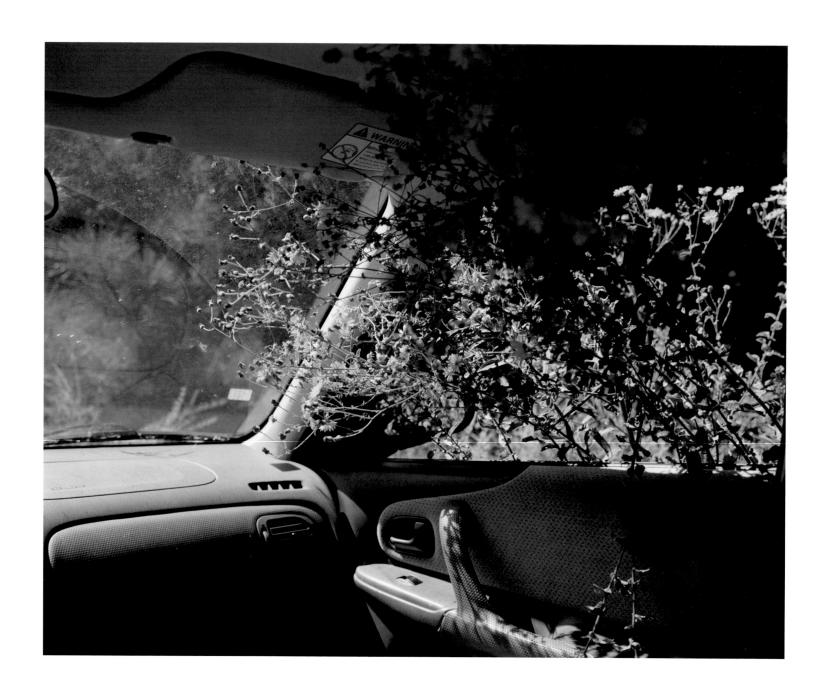

96 Georgia Rhodes, *Road Trip*

What We Feel in Our Bones MARTIN LAMMON

One night a woman tells me, "I wouldn't have the courage
to kill myself, or the instinct." Her fingers
stroke the bones that wrap around her eyes.
She rubs the hollows between bones.

I remember Senior Anatomy, the cat's
skeleton, how Mr. Mitchell traced his finger along
lumbar and thoracic vertebrae up to where the medulla
oblongata would attach to the neck's stem. The skull
looked to me like a girl's fist, and I wanted
to hold it in my hands, my thumbs laid against
each zygomatic arch—as if cheekbones might be
a portal to a new kind of heaven where
infinitesimal gods plotted inside a cat's head.

Where do you scribble an answer like that on the teacher's
quiz? What do you say to a woman
who rubs her eyes as if she'd stared too long at the sun,
or down, where new snow glitters
like god-fire? You say nothing. This is the way
love ends, the way your hands go numb,
then toes, the way an old man
feels in his bones there's no one
who will rouse him from his bed.

Local Men TRAVIS DENTON

They're the ones you read about in the papers,
Never good news. For Example: *Local Man, Found Face Down*
In His Teriyaki at Bill's Lucky Buddha, Foul Play Suspected.
Look around, gaggles of local men,
Just waiting to be picked off—thrown in the back
Of a rusted-out Buick (said car last seen speeding
Away from the Circle K). Hog-tied, drugged, stripped,
And left on Main Street. Local men aimed
For blunt force trauma of all kinds—you name it,
A 2x4 will do the job, candelabra, a length of iron pipe.

Wrong turns, blown red lights, each turn of the key
Has hurried them here, yet they appear surprised
When the strange car pulls up beside them
As they exit the wash-o-mat.
Their checkered pasts, like a one-legged runner, laps them.
They are lost wallets, keys that just go missing—lives
Summed up in two inches of newsprint.
They are not the last of the Mohicans.
Not the last dodo to lie down somewhere on the back forty.
But, a brown coat, scuffed shoes, a partial thumbprint,
A moustache sitting on a bar stool
In a local bar, who none of the other locals notice
Until the cops show up with photo asking,
Have you seen this man?

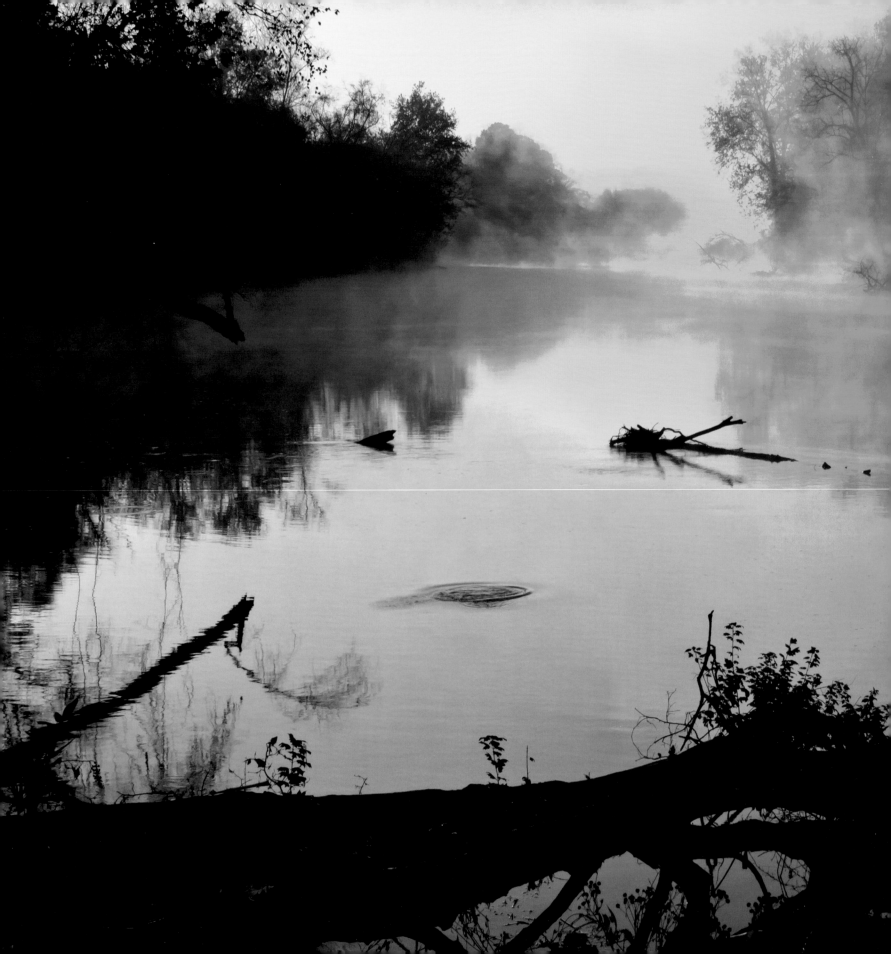

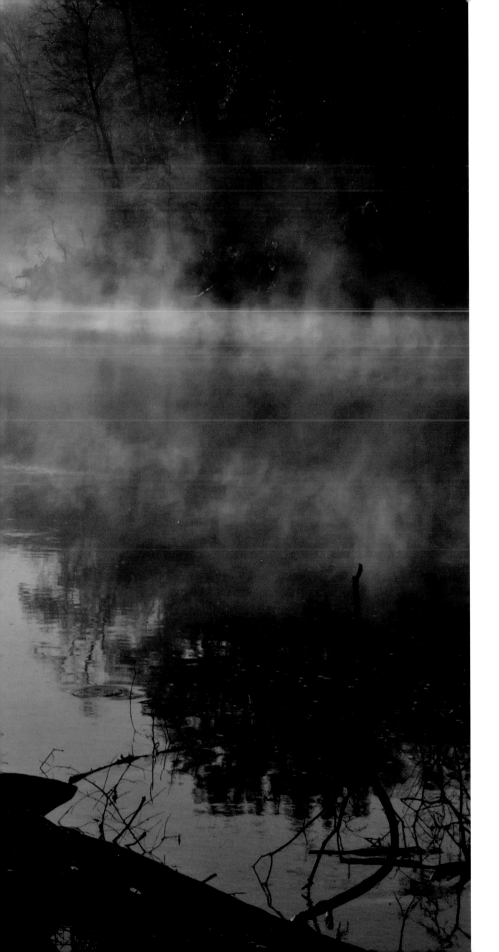

Chet Burgess, *Chattahoochee Dawn* (2010)

The Hesitation Pitch RALPH TEJEDA WILSON

for Luis Tiant

Even my Mexican mother, having little use for *cubanos*,
loved him. Her private cheer: *U - G - L - Y, he ain't got no alibi*!
meant with affection. On the mound in Cleveland,
that black stump of a man with too-long arms
he could uncoil over the top, sidearm, or suddenly submarining:
leaving the hitters shaking their heads, staring, or bailing all the way out.
Through the dull factory grind of summer when the lake stank
of algae and Dow Chemical, the skyline fogged its curious shade of brown,
the Indians firmly, typically, in the cellar, he would be there
every fourth day like clockwork, warming up with his long underwear
showing, a golf ball of tobacco tucked in one cheek.
Back then, Detroit had Kaline, and Boston, Yastremski;
the Robinsons were in Baltimore: cities we knew as bad
as ours, but with teams that made them look better.
Better surely than Tiant in his first *Game of the Week* interview,
approaching the camera as if it might steal
his soul, magnifying instead the flat wedge of his nose and broken
English. It would be hard, but we would have to keep on waiting,
waiting as we had always waited, huddled in the collective memory
of Lou Boudreau and 1948, waiting finally for justice,
finally for Tiant on the bald hill of the mound,
serving up air: fastballs that rose or dropped by turns,
sliders, curves, the knuckler: whatever he concocted to do
the one job he was meant to do over and over again.
And we would be waiting for what Herb Score called
the *hesitation pitch*, that deliberately corkscrewed delivery
that turned him for a moment out toward center field
to face the vast wasteland of bleachers, the two-dollar seats
from where we could see him almost plainly hiding the ball,
sweating, sneering as he worked up the juice,
the whole time giving them his back.

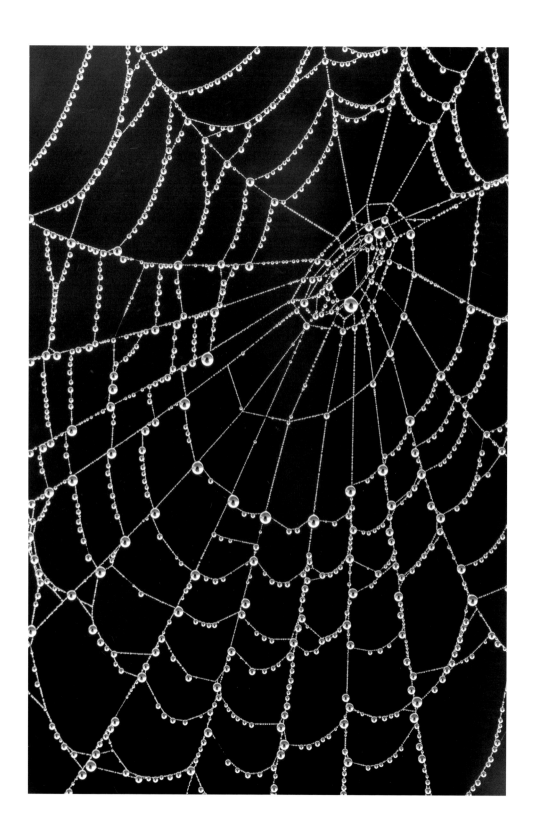

David Foster, *Web of Pearls* (2014)

Betty Jo Jackson JERICHO BROWN

There's a story my father likes to tell.
 Never mind. My father's never been good
At stories, and I wouldn't want you calling me
 A gossip. Besides, this is about my mother.
I wouldn't want you calling her a fool. How
 Might you have handled things? You see
Your man approached by a girl whose hair is longer
 Than her skirt. Well, Mama was nicer
Than you. She simply moved from her place
 Behind the college cafeteria counter
And stared for a long time, first at the foreign
 Hands that held my daddy's elbow, then
Right into that poor girl's eyes.
 You know it – the look
A neighbor gives when, during a visit,
 You bump and break a perfect
Piece of crystal the shape of a dove.
 I guess you can tell why Daddy loves
This story so much, he, a one-eyed prize
 With a woman on each side of him.
To the left, a miniskirted Sapphire
 With red fingernails to match.
To the right, hair-netted, aproned,
 And ready to risk her work-study,
A woman you might mistake for Jemima
 If her eyes weren't fierce enough to push
A harlot away in whimpers. Betty Jo
 Jackson, I think, was the girl's name. Ask
My daddy. He won't forget: my mother
 Calm, but close to violence, she-wolf set
To claw and devour. I guess you can tell
 Why I'm so jealous of Betty Jo. She got
To see my mother back when she still
 Wanted a fight. I wish I had known Mama
Then. I would have loved her that way.

Song of the Black Corona KEVIN CANTWELL

In this bright wind we like to show you
where the dead have stood & long since then where we

have put them down; where one lay down, all
sparks across Hillcrest Avenue, his broken

bike; where one, like a dragged chain, slid his
down Napier; both leaned through the curves; both laid out

a year apart, side by side, beneath
their matching slabs; one with a six-string lead etched

in stone; one, a bass guitar engraved.
"Young" Stribling has his own memorial bridge,

the muddy swirl below; he had gunned
his Indian—coming or going no one

now can say—down Forsyth Road or
up that road; the body of that pugilist,

the Canebrake King, cracked like a dropped egg;
his bridge rumbles all night long beyond the woods.

One, let us show you now, cut in stone,
a ball bat & a·glove, hanged himself in jail.

In this bright wind we like to show you
by stepping back from where we stand, *This is where*

he stood & this is what he said. One,
on LSD, got lost all night long between

two watersheds; & come next day jumped
two loggers & pounded on their rig; naked

& livid, he whipped at them with snakes;
until a sheriff, then his back-up, & then

the whole day shift of those country boys,
that night, had to take him down, & midnight then

he was the one who hanged himself; &
Michael, first among us born & first to go,

would cut the path himself; would quote, when
he made time come to him, the Gospel of John

where the living water always spills.
We will take you down Walnut Street, bounce along,

across the James Brown, the *I-feel-good*
Bridge; or cross the Redding span; & sometimes

back at night we'll come singing;
sometimes, in the reeds below, just the sleepless

birds. Sometimes this tour means living here;
coffee in hand; a cigarette; a hard clutch

slipping up the hill, the stick someone
riding passenger will have to persuade in-

to gear. We know by heart, in this town,
we know by rote, where the railroad tracks come near

Elizabeth Reed, across the way
from those hippie brothers, side by side. They're down

Rose Hill from where a friend was lowered.
Cranked on speed, he drove a car into the dark

underpass, filmed that month in Huston's
Wise Blood, the black blossom where he burned up burned

in concrete, faded by all these years;
but in that sweeping shot of the road from town—

as fresh today as then. Once, we pitched
a yellow tarp in some woods where light has made

houses stand amazed. Downhill—the huge,
watery sun. He & his common law wife-

to-be, back-lit by the early light;
their bodies, stamen & pistil, their limbs, slow

as bees in early frost; my old friend,
black flower now for good, but in that yellow

corolla then (her red wool socks, her
white legs), there were other pleasures of the flesh.

March WYATT PRUNTY

Seeing the March rain flood a field
So suddenly the water stands
Seeping from sight, while at the fence
The wind rags up a bare-limbed argument
On which a hawk rises, circles,
Then pumps from sight under clouds clotted
And driven so the bunched low sky
Stampedes in blundering shapes
So changeable they disprove shape—
And then the rain again, in which
The clouds come down but differently,
Driven and driving, blunted or edged,
As now how will it be when what
We call a shift in season
Blusters, or storms, or goes dead still
With us left standing underneath
To wonder or ignore the change
From overhead to underfoot,
Going on regardless where we've gone,
Who we were, what we ever said or did?

David Ferguson, *Too Tired* (2010)

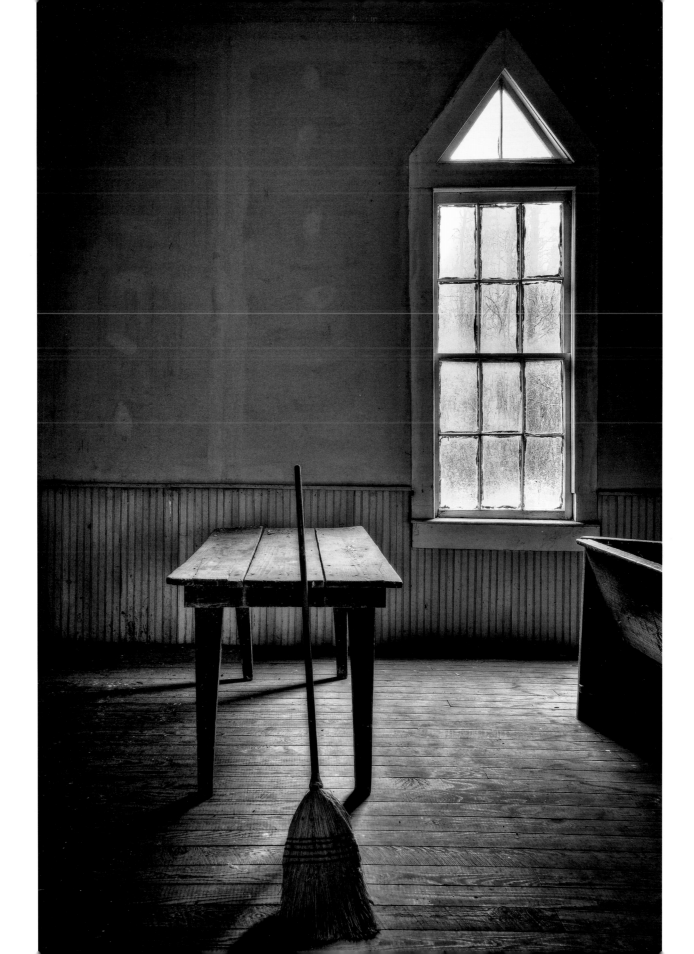

No, it's not ANYA SILVER

The body of Christ, the priest murmurs,
placing a morsel of bread in my palm.
Only I hear my son whisper, *No, it's not*.
Eight-year-old skeptic, creed-smasher,
how to stop the erosion of what's possible?
Or unhook faith from what can be seen?

One evening, strolling the Jersey bay,
we took flailing horseshoe crabs
by their spiny tails, tossing them into tides
so they could glide back to the deep sea.
And wasn't that impulse, to save the ugly,
Love? My doubter, miracle-denier,
may God hurl your spikey edges into the waves.
May you be cradled in His body forever.

Love Worn LITA HOOPER

In a tavern on the Southside of Chicago
a man sits with his wife. From their corner booth
each stares at strangers just beyond the other's shoulder,
nodding to the songs of their youth. Tonight they will not fight.

Thirty years of marriage sits between them
like a bomb. The woman shifts
then rubs her right wrist as the man recalls the day
when they sat on the porch of her parents' home.

Even then he could feel the absence of something
desired or planned. There was the smell
of a freshly tarred driveway, the slow heat,
him offering his future to folks he did not know.

And there was the blooming magnolia tree in the distance—
its oversized petals like those on the woman's dress,
making her belly even larger, her hands
disappearing into the folds.

When the last neighbor or friend leaves their booth
he stares at her hands, which are now closer to his,
remembers that there had always been some joy. Leaning
closer, he believes he can see their daughter in her eyes.

Unengaged ERIN GANAWAY

A half moon anchors on this espresso night,
and she says she can smell the stars,

like a skinned grapefruit, bursting sharp
against her nostrils. She flattens her palm,

swims it at an angle so the diamond catches
the moonlight. She says she snagged his star,

grappled with it and hitched it to her finger.
She leans into him, like a filly wobbling

for warm milk, and she shuts her eyes to close
out what he has told her. Days from now,

when this moon is drained from the sky,
when her star has rejoined the others, she will have

only a phantom limb. She will make a fist to keep
the ring from slipping as she washes her hands.

Her breath will hover when she sees it missing and
resume when she remembers where it has gone.

Pretty Little Rooms KATIE CHAPLE

The remains of who was thought to be the Renaissance poet Francesco Petrarch are instead those of two different people, DNA tests have confirmed.

The skull was unexpected, a surprise in the pink marble tomb.
In 1873, the old doctor of Padua claimed it had crumbled,
as though too injured to live outside that stone room.
Did he keep it on his desk? On his shelf as a specimen,
an exemplar of perfection, the knitted plates
a symbol of all that we cannot know of love?

The doctor was not the only man who needed—a friar fled
his flagged cell, hacked off the poet's arm, spirited it back,
a drunk friar in such grief for the world, so moved
as to steal the physical. And where and how to keep it—
this limb that had once moved to love's measure?

And now, these scientists with their test tubes, their milliliters
and tweezers are used to wounds and hairs, blood
and shatter. In their white coats and labs, they don't ask
questions they don't know the answers to. They brush
away quarry dust, measure the circumference, count the alleles,
and approximate the years—all equating female.
Nobody asks: Whose body was not loved enough
that her skull could travel like a pebble,
could be used to punctuate the line of a man's body?

Landscape and Elegy LAURA NEWBERN

This morning the sun rose, and the people stirred.
Though in their stirring they couldn't
be seen—only the blue sky, and the white,
and the brick, and the lone cedar
hugging the side of their home. . .
After a death, after an old woman
(very old) is lowered into the ground, the sun
rises the same; the birds make
the same cacophony up in the tops
of the yards. And a Sunday looks
like a Sunday. One
wonders, maybe, a little bit more about
the stirring, the people across, waking—
the girl's foot's first touch
of the clean floor; or the father's opening one eye
and gently awaiting the other. . .
 She was lowered
slow as a beam, and with the same
angular, unresistable swing, left to right,
and again to the right, and in a pale blue robe
is how she was dressed. Though nobody saw except
the one who dressed her,
in a low room, while the sun rose.
It was early. And it was tender.

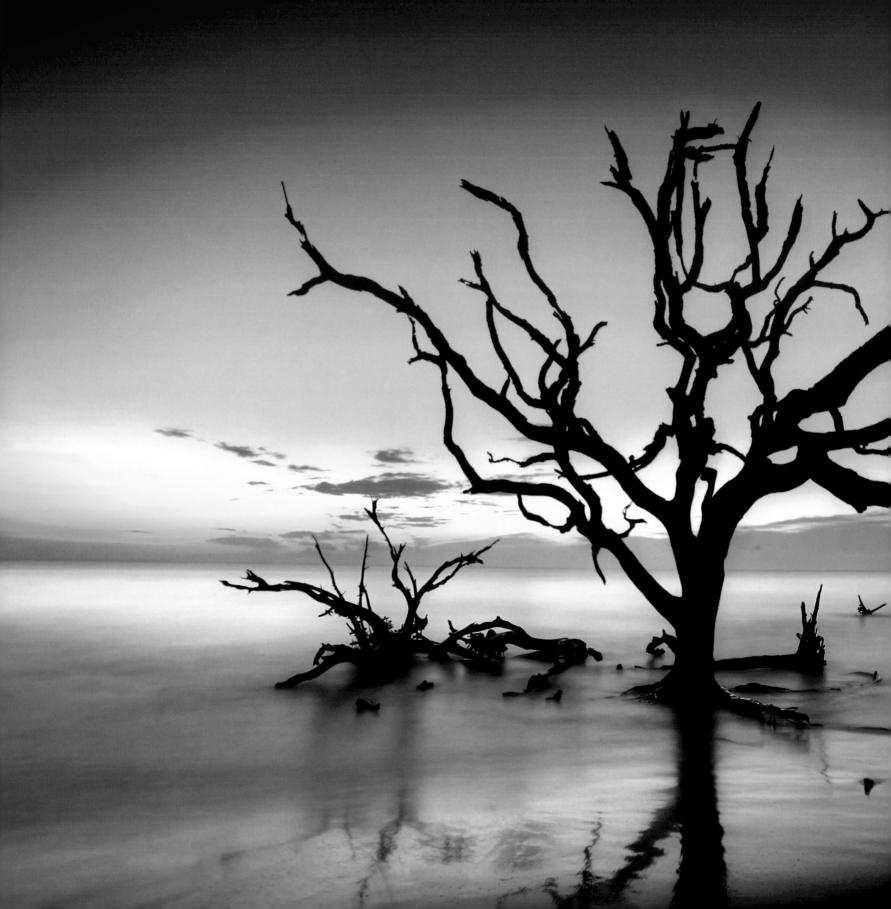

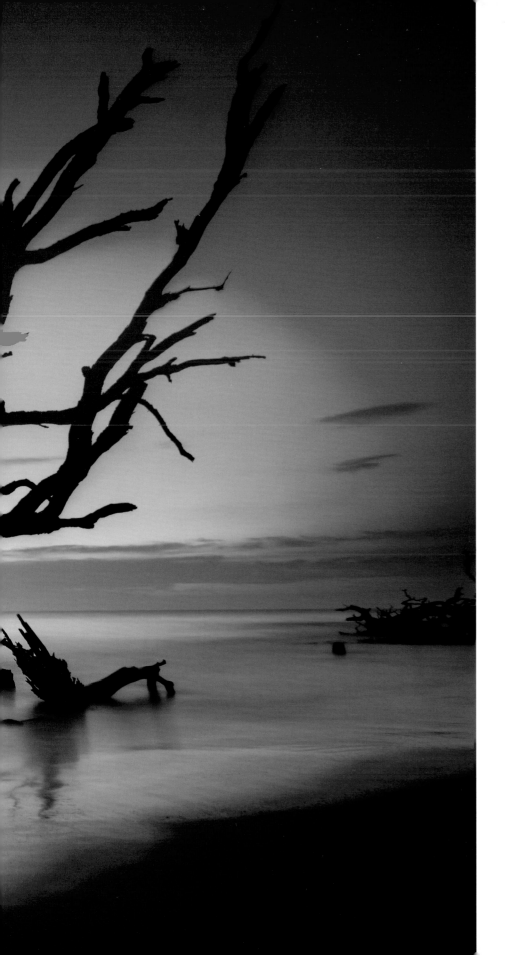

Douglas Stratton, *Break of Day* (2013)

A Raft of Grief CHELSEA RATHBURN

"The *raft* that means 'a great number' is not related at all to the *raft* that carries people or their possessions in the water.
The two words are homonyms . . ."—*Morris Dictionary of Word and Phrase Origins*

If only there *were* a boat,
low and long and loaded
with all we'd brought or built:
the fatal inattentions,
anxieties and tics
that time had sanctified,
our good and bad intentions,
rages, lapses, and aches.
If only it were that easy,
to stand only ankle-
deep in the sullied water
hoisting our shared cargo,
sinking no further beneath
its weight. If only the boat
did not need a rower;
we'd push it off together
then wade to opposite banks
absolved at last, forever,
buoyant, watching it go.

Natural Occurrences SHARAN STRANGE

Once I pried open my doll's head
seeking a nest of silken hair inside.
But there was none. No inner parts, no
tongue. Just the stubble of glued blond
tufts behind sky-colored, dumb, unrooted eyes.
Odd to find it hollow,
like a fallow garden or a river's empty bed.

I thought I'd find some answer
to the mystery of my own hair,
not smooth or flowing like a doll's
but kinked, knotted, painful to be combed.
Tender-headed, my grandmother called me
as she tugged the stubborn tangles and I cried
until she warned my heart would burst.

She'd say I was *full of woe*, which,
sounding religious, pleased and scared me—
the way I'd felt beheading that doll.
But it was a dead thing that, despite
my tortures, couldn't cry, or understand
the world as I would someday, or why
its falseness made me angry and sad,
and why tears were good.

Laura Noel, *Secrets Scanned* (2014)

Above It All SEAN HILL

At 33,000 feet above sea level the elbow
of the man in front of me, who is as dark
as my younger brother, good chocolate—
bittersweet—dark, rises above the blue
headrest like the Rock of Gibraltar
in negative, black and alive and trying
to get comfortable; I'm almost as surprised
by my desire to touch it as when I visited
home, so long gone, and my brother's
twenty-five-year-old body startled me,
grown, lounging in his boxers, nonchalant
in his skin (still living in that house); I didn't
recognize him since I hadn't watched
him the way I do the ground (always
a window seat, so I can see how far
we'll fall) out this window—the middle
of the country, a quilt pieced from
generations of scraps folded in a chest
at the foot of a farmhouse bed, looks
nothing like the coasts with their tightly
packed subdivisions with kidney pools
and cul-de-sacs looking like that map
of the lungs Nana taught me when I
was ten—bronchioles and alveoli,

and near the end I didn't know how to read
the X-rays of her pancreas (from the Greek
words for *all* and *flesh*); I imagined tumors
as smooth as the moon from where I sit—
pearls with their grain-of-sand hearts—
and out the other side dragged across
the horizon, the color under God's fingernails,
a blush among the clouds, the wine and bread
of the body and blood, or the finger that gives
life brushed by Michelangelo in the Sistine Chapel—
the Creation of Adam—and I wonder how I am made.

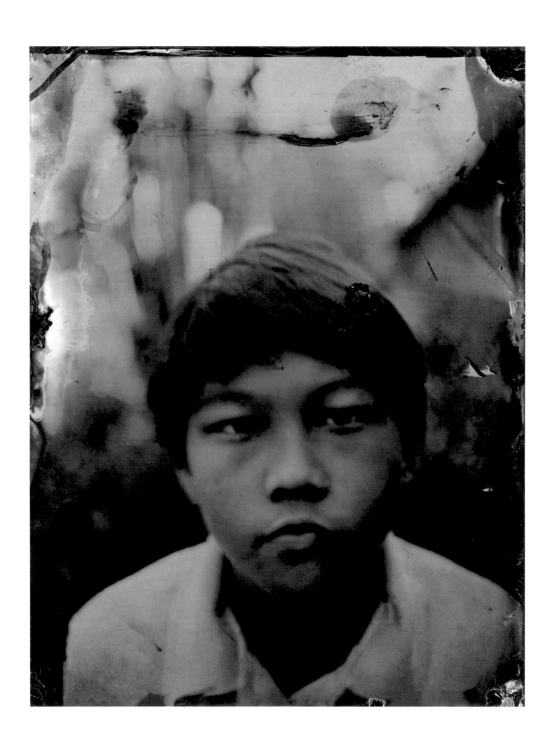

Karey Walter, *Wet Plate Collodian #20* (2014)

Under the Vulture Tree DAVID BOTTOMS

We have all seen them circling pastures,
have looked up from the mouth of a barn, a pine clearing,
the fences of our own backyards, and have stood
amazed by the one slow wing beat, the endless dihedral drift.
But I had never seen so many so close, hundreds,
every limb of the dead oak feathered black,

and I cut the engine, let the river grab the jon boat
and pull it toward the tree.
The black leaves shined, the pink fruit blossomed
red, ugly as a human heart.
Then, as I passed under their dream, l saw for the first time
its soft countenance, the raw fleshy jowls
wrinkled and generous, like the faces of the very old
who have grown to empathize with everything.

And I drifted away from them, slow, on the pull of the river,
reluctant, looking back at their roost,
calling them what I'd never called them, what they are,
those dwarfed transfiguring angels,
who flock to the side of the poisoned fox, the mud turtle
crushed on the shoulder of the road,
who pray over the leaf-graves of the anonymous lost,
with mercy enough to consume us all and give us wings.

To Understand *El Azul* JUDITH ORTIZ COFER

We dream in the language we all understand,
in the tongue that preceded alphabet and word.
Each time we claim beauty from the world,
we approximate its secret grammar, its silent
syntax; draw nearer to the Rosetta stone
for dismantling Babel.

If I say *el azul*, you may not see the color
of *mi cielo, mi mar*. Look once upon my sky,
my sea, and you will know precisely
what *el azul* means to me.

Begin with this: the cool kiss
of a September morning in Georgia, the bell-shaped
currents of air changing in the sky, the sad ghosts
of smoke clinging to a cleared field, and the way
days will taste different in your mouth each week
of the season. *Sábado*: Saturday
is strawberry. *Martes*: Tuesday
is bitter chocolate to me.

Do you know what I mean?

Still, everything we dream circles back.
Imagine the bird that returns home every night
with news of a miraculous world just beyond
your private horizon. To understand its message,
first you must decipher its dialect of distance,
its idiom of dance. Look for clues
in its arching descent, in the way it resists
gravity. Above all, you have to learn why
it aims each day

toward the boundless *azul*.

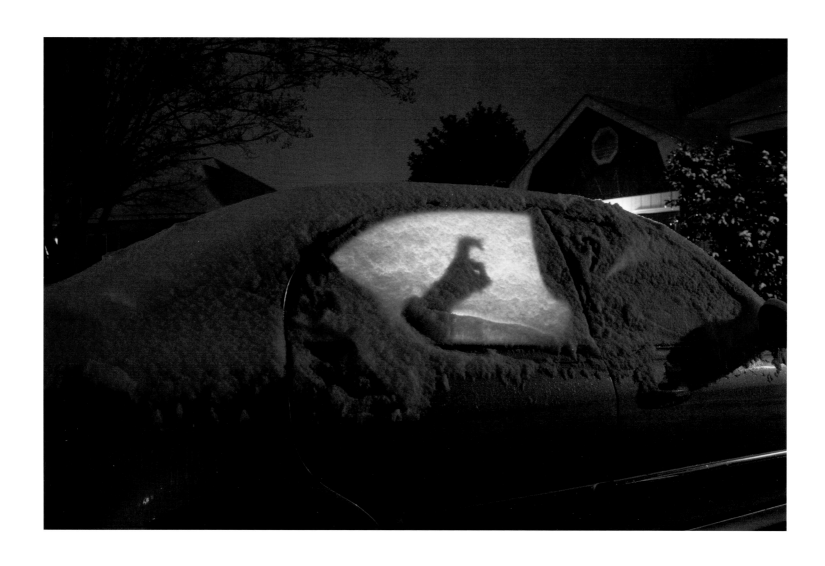

Christina Hadley, *Playboy* (2013)

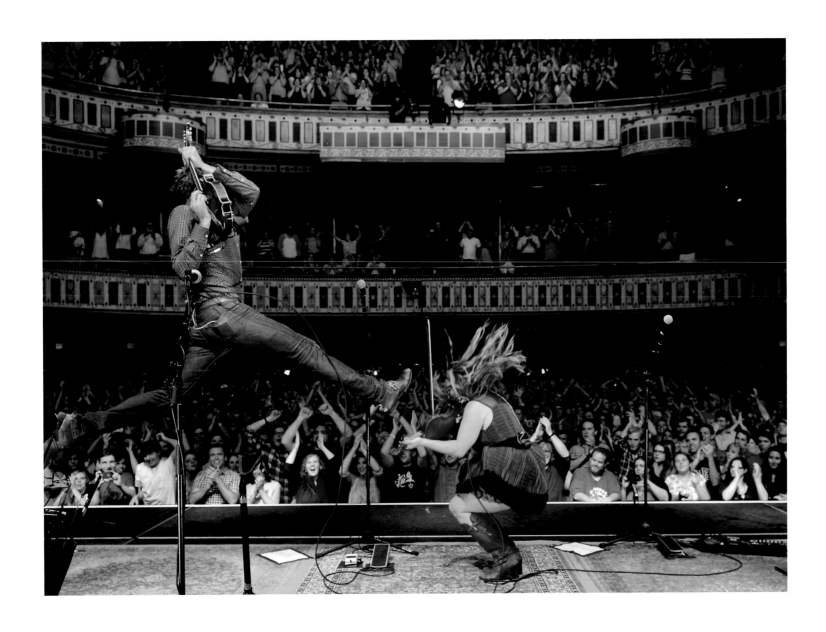

Perry Julien, *Nickel Creek at The Tabernacle* 129

Negative KEVIN YOUNG

Wake to find everything black
what was white, all the vice
versa—white maids on TV, black

sitcoms that star white dwarfs
cute as pearl buttons. Black Presidents,
Black Houses. White horse

candidates. All bleach burns
clothes black. Drive roads
white as you are, white songs

on the radio stolen by black bands
like secret pancake recipes, white back-up
singers, ball-players & boxers all

white as tar. Feathers on chickens
dark as everything, boiling in the pot
that called the kettle honky. Even

whites of the eye turn dark, pupils
clear & changing as a cat's.
Is this what we've wanted

& waited for? to see snow
covering everything black
as Christmas, dark pages written

white upon? All our eclipses bright,
dark stars shooting across pale
sky, glowing like ash in fire, shower

every skin. Only money keeps
green, still grows & burns like grass
under dark daylight.

Adam Forrester, *Cloverdale* (2014)

Kitchen Maid with Supper at Emmaus; or, The Mulata

NATASHA TRETHEWEY

After the painting by Diego Velázquez, c. 1619

She is the vessels on the table before her:
the copper pot tipped toward us, the white pitcher
clutched in her hand, the black one edged in red
and upside-down. Bent over, she is the mortar,
and the pestle at rest in the mortar—still angled
in its posture of use. She is the stack of bowls
and the bulb of garlic beside it, the basket hung
by a nail on the wall and the white cloth bundled
in it, the rag in the foreground recalling her hand.
She's the stain on the wall the size of her shadow—
the color of blood, the shape of a thumb. She is echo
of Jesus at table, framed in the scene behind her:
his white corona, her white cap. Listening, she leans
into what she knows. Light falls on half her face.

Benediction Bruce Beasley

In olden times, when wishing still helped . . .—Grimm's Fairy Tales

Let the dead stars
fume and burn,
wherever they are.
Let the raw
color of carnations
survive,
white against red.
Let the funeral home
by the Farmer's Market
go on with its planting
and burying,
its hanging flowers
shrouding the wooden porch.
Let the impatiens and morning glories
always surround the hearses.
Let the children go on wishing
on the stars'
borrowed light, even when
it won't help, when the moon
is spare, three-quarters black,
lodged
at the night's rim
like a mote in the eye.
Even when the sky
is dull with stars, when they've all
sputtered out, one by one,
and kept
burning. . .
Let us still
see them. Let us
believe there is someone
when we mourn or pray
who will listen,
who will bend down.

Notes on the Contributors

The Poets

COLEMAN BARKS taught at the University of Georgia. He was inducted into the Georgia Writers Hall of Fame in 2009. "Hummingbird Sleep" is from *Hummingbird Sleep*, University of Georgia Press, 2013.

BRUCE BEASLEY is a native of Macon and teaches at Western Washington University. "Benediction" is from *Spirituals*, Wesleyan University Press, 1988. Reprinted by permission of the author.

STEPHEN BLUESTONE taught English and film at Mercer University. "The Closing" is from *The Flagrant Dead*, Mercer University Press, 2007.

DAVID BOTTOMS served as the poet laureate of Georgia from 2000 until 2012. He was inducted into the Georgia Writers Hall of Fame in 2009. "Under the Vulture Tree" is from *Under the Vulture Tree*, William Morrow, 1987.

JERICHO BROWN teaches at Emory University. "Betty Jo Jackson" is from *Please*, New Issues Poetry & Prose, 2008.

KATHRYN STRIPLING BYER is a Georgia native. "Diamonds" is from *Wildwood Flower*, Louisiana State University Press, 1992.

KEVIN CANTWELL teaches at Middle Georgia State University. "Song of the Black Corona" is from *Something Black in the Green Part of Your Eye*, New Issues Poetry & Prose, 2002.

KATIE CHAPLE teaches at the University of West Georgia. "Pretty Little Rooms" is from *Pretty Little Rooms*, Press 53, 2011.

JUDITH ORTIZ COFER taught at the University of Georgia. The Puerto Rico-born Cofer was inducted into the Georgia Writers Hall of Fame in 2010. "To Understand *El Azul*" is from *A Love Story Beginning in Spanish*, University of Georgia Press, 2005.

STEPHEN COREY edits *The Georgia Review*. "Quilts" is from *The Last Magician*, Water Mark Press, 1981. Reprinted by permission of Stephen Corey.

ALFRED CORN is a Georgia native. "Apartment on 22nd St." is from *The West Door*, Viking Penguin, 1988.

CHAD DAVIDSON teaches at the University of West Georgia. "In Ravenna" appeared in *From the Fire Hills*, Southern Illinois University Press, 2014.

TRAVIS DENTON teaches at the Georgia Institute of Technology. "Local Men" is from *When Pianos Fall from the Sky*, Marick Press, 2012.

GREGORY FRASER teaches at the University of West Georgia. "Off Broadway" is from *Answering the Ruins*, Triquarterly Books/Northwestern University Press, 2009.

ALICE FRIMAN teaches at Georgia College and State University. "Tracing Back" is from *The View from Saturn*, Louisiana State University Press, 2014.

ERIN GANAWAY teaches at the University of North Georgia. "Unengaged" is from *The Waiting Girl*, Texas Review Press, 2013.

BETH GYLYS teaches at Georgia State University. "Ars Poetica" is from *Spot in the Dark*, The Ohio State University Press, 2004.

SEAN HILL is a native of Milledgeville. "Above It All" is from *Dangerous Goods*, Milkweed Editions, 2013.

LITA HOOPER lives in Atlanta. "Love Worn" is from *Gathering Ground: A Reader Celebrating Cave Canem's First Decade*, University of Michigan Press, 2006.

MARTIN LAMMON teaches at Georgia College and State University. "What We Feel in Our Bones" is from *News from Where I Live*, University of Arkansas Press, 1998.

ESTHER LEE teaches at Agnes Scott College. "The Real World is Like This" is from *Spit*, Elixir Press, 2011.

THOMAS LUX teaches at the Georgia Institute of Technology and runs the "Poetry at Tech" program there. "There Were Some Summers" is from *New and Selected Poems of Thomas Lux 1975–1995*, Mariner Books, 1999.

SANDRA MEEK teaches at Berry College. "Wind Event" is from *Road Scatter*, Persea Books, 2012.

JUDSON MITCHAM is a native of Monroe. He was named poet laureate of Georgia in 2012 and was inducted into the Georgia Writers Hall of Fame in 2013. "History of Rain" is from *This April Day*, Anhinga Press, 2003.

OPAL MOORE teaches at Spelman College. "Hit the Road Jack" is from *Lot's Daughters*, Third World Press, 2004. Reprinted by permission of the author.

ERIC NELSON taught at Georgia Southern University. "Art" is from *Terrestrials*, Texas Review Press, 2004.

LAURA NEWBERN teaches at Georgia College and State University. "Landscape and Elegy" is from *Love and the Eye*, Kore Press, 2010. Reprinted by permission of the author.

ED PAVLIC teaches at the University of Georgia. "Spheres" is from *Paraph of Bone & Other Kinds of Blue*, The American Poetry Review, 2001.

PATRICK PHILLIPS is a native of Atlanta. "My Lovely Assistant" is from *Chattahoochee*, University of Arkansas Press, 2004

WYATT PRUNTY grew up in Athens. He teaches at the University of the South and is the founding director of the Sewanee Writers' Conference. "March" is from *Unarmed and Dangerous*, Johns Hopkins University Press, 2000.

CHELSEA RATHBURN teaches at Young Harris College. "A Raft of Grief" is from *A Raft of Grief*, Autumn House Press, 2013.

JANISSE RAY is a native of Baxley. She was inducted into the Georgia Writers Hall of Fame in 2015. "Waiting in the Dark" is from *A House of Branches*, Wind Publications, 2010.

MEGAN SEXTON is a faculty member at Georgia State University. "Ode to Silence" is from *Swift Hour*, Mercer University Press, 2014. Reprinted by permission of Mercer University Press.

ANYA SILVER teaches at Mercer University. "No, it's not" is from *I watched you disappear*, Louisiana State University Press, 2014.

CHARLIE SMITH is a native of Moultrie. "Women of America" is from *Jump Soul*, W.W. Norton, 2014.

R. T. SMITH grew up in Georgia. "Fence" is from *The Cardinal Heart*, Livingston University Press, 1991.

RON SMITH is a native of Savannah. "Sleeping on the North Rim" is from *Moon Road*, Louisiana State University Press, 2007.

A. E. STALLINGS is a native of Decatur. "Prelude" is from *Hapax*, Triquarterly Books/Northwestern University Press, 2006.

LEON STOKESBURY teaches at Georgia State University. "The Luncheon of the Boating Party" is from *Autumn Rhythm*, University of Arkansas Press, 1996.

SHARAN STRANGE teaches writing at Spelman College. "Natural Occurrences" is from *Ash*, Beacon Press, 2001.

NATASHA TRETHEWEY teaches at Emory University. The former U.S. poet laureate won the Pulitzer Prize in Poetry for her collection *Native Guard*. "Kitchen Maid with Supper at Emmaus; or, The Mulata" is from *Thrall*, Houghton Mifflin Harcourt, 2014.

MEMYE CURTIS TUCKER lives in Atlanta. "Matisse" is from *The Watchers*, The Ohio University Press, 1998.

KELLY WHIDDON teaches at Middle Georgia State University. "Folk Lore" is from *The House Began to Pitch*, Mercer University Press, 2012.

RALPH TEJEDA WILSON teaches at Kennesaw State University. "The Hesitation Pitch" is from *A Black Bridge*, University of Nevada Press, 2001.

KEVIN YOUNG teaches at Emory University. "Negative" is from *To Repel Ghosts*, Alfred A. Knopf, 2005.

ANDREW ZAWACKI teaches at the University of Georgia. "Credo" is from *Anabranch*, Wesleyan University Press, 2004.

The Photographers

H. GAY ALLEN, a longtime resident of Atlanta, is an art photographer with a special interest in digital work.

TAYLOR BAREFORD lives and teaches at the Art Institute of Atlanta.

WILLIAM BOLING is an Atlanta-based photographer who operates Fall Line Press, an independent art and photobook publishing house, bookstore, and reading room.

LUCINDA BUNNEN'S work has been exhibited and collected by national and international museums.

CHET BURGESS lives in Atlanta and specializes in landscape photography.

Originally from Argentina, MARK CACERES moved to Atlanta with his parents when he was eleven and has remained in Georgia since.

After a stint as a farmer in Tattnall County, KEN CALLAWAY taught art for twenty years outside Atlanta, but plans to devote himself to photography and gardening in retirement.

LINDA COATSWORTH is an Indiana transplant who has lived in Georgia since 1971.

JOEFF DAVIS has taken pictures in Georgia for the last decade.

HARRIET DYE is a longtime resident of metro Atlanta.

DAVID FERGUSON is retired from business.

Native Georgian ADAM FORRESTER was born in Columbus, studied in Athens, and lives in Atlanta.

DAVID FOSTER lives in Decatur and exhibits his work across Georgia.

JENNIFER GILIBERTO was raised in Connecticut and writes and photographs in Atlanta.

MAURY GORTEMILLER lives in Decatur.

AMANDA GREENE was born in Clayton.

CHRISTINA HADLEY recently graduated from Columbus State University in Columbus. She is inspired by self-identity.

JESSICA HINES resides beside a Georgia swamp, surrounded by the natural world.

PERRY JULIEN is a New Yorker living in Georgia.

DIANE KIRKLAND is a former marketing photographer for Georgia and enjoys exploring and photographing the South.

JUDY LAMPERT is from and works in the South.

Despite BEN LEE'S early years of travel, Georgia is and always will be his home.

JAMIE MACIUSZEK lives in Atlanta.

Georgia raised SHOCCARA MARCUS, and she is very proud of it.

CARL MARTIN has lived in Athens, Georgia, for 25 years.

ERIN MAZZEI lives in Athens.

FOREST McMULLIN teaches at the Atlanta campus of the Savannah College of Art and Design.

TOM MEISS was born and raised in Pennsylvania, but has made Atlanta his home since 1982.

MARY ANNE MITCHELL is a native of Georgia, and its nature and light informs her art.

LAURA NOEL is an Atlanta native and holds a Masters of Fine Art degree with Distinction in Photography from the University of Georgia.

CAITLIN PETERSON studied photography at the Savannah College of Art and Design.

MICHAEL REESE lives in Atlanta.

GEORGIA RHODES moved to Athens from Michigan.

Born in Selma, Alabama, and living in Atlanta, JERRY SIEGEL'S work focuses on the people and character of the Black Belt of Alabama.

RYLAN STEELE lives in Columbus with his wife and son.

DOUG STRATTON is an Atlanta-based fine art and travel photographer whose passion for photography stems from a deep desire to capture the world around him.

JOHN SUMNER has been documenting people and places throughout American South for nearly fifty years.

MERYL TRUETT moved to Georgia after visiting Savannah with her book club, which was reading Flannery O'Connor.

KAREY WALTER was born in Pittsburgh, Pennsylvania, and currently lives in Atlanta, where she teaches photography at the Lovett School.

YANCEY is a 2012 graduate of the Art Institute in Atlanta with a degree in photographic imaging.

Notes on the Partners

ATLANTA CELEBRATES PHOTOGRAPHY is a nonprofit arts organization dedicated to the cultivation of the photographic arts and the enrichment of the Atlanta arts community. ACP aims to make Atlanta a leading center for the world's fastest growing art form. Primarily by producing the largest annual community-oriented photo festival in the United States, ACP provides experiences that engage and educate diverse audiences through lens-based media.

GEORGIA COUNCIL FOR THE ARTS is a division of the Georgia Department of Economic Development whose mission is to cultivate the growth of vibrant, thriving Georgia communities through the arts. GCA provides grant funding, programs, and services statewide that support the vital arts industry, preserve the state's cultural heritage, increase tourism, and nurture strong communities. Funding for Georgia Council for the Arts is provided by appropriations from the Georgia General Assembly and the National Endowment for the Arts.

GEORGIA HUMANITIES promotes and preserves the stories and cultural legacies of the state's people—from the past to the present and into the future—to enrich their lives and strengthen their communities. An informed and educated Georgia understands historical and cultural trends, respects the life of the mind, utilizes critical thinking in decision making, and promotes mutual respect and civility. Funding for GH is provided by the state of Georgia, the National Endowment for the Humanities, foundations, donors, and our partners.

Since its founding in 1938, the primary mission of the UNIVERSITY OF GEORGIA PRESS has been to publish books that make a difference for the citizens of Georgia and the world—books that present important new scholarship, raise awareness about pressing environmental and conservation issues, interpret our region, and contribute to the literary culture of our time. We support and enhance the university's place as a major research institution by publishing outstanding works of scholarship and literature by scholars and writers throughout the world.